The MIT Press Cambridge, Massachusetts, and London, England

Drawings by the author.

The author wishes to acknowledge the editorial assistance of
Frank Carlton.
This book was printed by Rapoport Printing Corp.
and bound by Sendor Bindery, Inc.
in the United States of America.

Library of Congress Cataloging in Publication Data

Piene, Otto, 1928-
 More sky.

 "Part I: Things to do, A-M. Part II: Wind manual,
I, II, III."
 1.Art--Themes, motives. 2.Kites--Pictorial works.
3.Flags--Pictorial works. 4.Balloons--Pictorial works.
I.Title.
N7560.P54 704.94 72-8411
ISBN 0-262-16054-4
ISBN 0-262-66017-2 (pbk)

OTTO PIENE * M·I·T·PRESS

MORE SKY

Contents

In the heat of the debate over the new taxation laws,
Sherman Lee, director of the Cleveland Museum of Art, is
said to have taken the stand that collectors ought to be
permitted to make tax deductions for art donations to mu-
seums but that artists ought not to be allowed to make
similar deductions. In other words, Mr. Stockbroker would
derive radical economic benefits from his love for art
while Alexander Calder, who could deduct only the cost of
materials when donating a work to the Museum of Modern Art,
would not.

This position is typical of an attitude that might be
described as "Capitalistic Platonism": the artist who cannot
avoid getting his hands dirty while he is producing a work
of art is understood to be clearly inferior to the buyer/
connoisseur/manipulator of art, the white-collar guy who
watches, as opposed to slaving over, matter.

Something tangible they want, those tax-deducting people,
artists' labor they need, those tax-deducting people, be-
cause they usually do not want to buy something considered
mere spirit, a fugitive phenomenon—as a prominent collec-
tor put it, pointing at some light environment that did not
incorporate the usual objects, "What good is it, you can't
buy it!"

The blue-collar/white-collar dichotomy is traditional. One
of Leonardo's main arguments for the superiority of painting
over sculpture is that the painter hardly gets his hands

dirty and listens to music while working, while on the other hand the sculptor sweats and aches in his dusty studio creating his artistic children.

Kenneth Baker, a young critic whom I respect, expressed to me his doubts about the value of the physical participation of the audience in art. It is his view that physical participation keeps the audience from thinking. I conclude that Mr. Baker believes that only the thinking man is a noble man and that insights that come during physical involvement are by definition inferior to insights that result from contemplation. Kenneth Baker seems to have decided that the physical involvement of author and audience during environmental/elemental events results in the eventual politization of that audience—again because the audience does not have the time to sit back and think.

Let me very simply make this rejoinder: as much as one can doubt the validity of physical and emotional involvement, one can equally doubt the validity of an elitist attitude toward art and life. We all know there are just as many white-collar bandits as there are blue-collar criminals. The select audience that the elitist artist (and historian and critic) dream of can be a bunch of snobs as easily as it can be a group of sensitive beings. The idea of excellence as an exclusive value is basically royalist, a funny concept by any standards of sanity and social responsibility. Excellence ought to be apparent in the environment rather than hidden in a private jewel box.

Sometimes I get to feeling that some creepy creature of an intellectual must have invented what is a typically American psychosis: a sense of guilt about planning an environment for many, of undemocratic treason in seeking the betterment of everybody's environment. The feeling that it is every citizen's right to mess up his share of the country is the stepchild of an old-fashioned liberalism. If you adherents of such a liberalism want to argue what follows, be welcome. Despite all the actual and the potential and desirable social changes that may occur, the artist is still a person trained and willing to shape small or large objects, stretches of land, small or large portions of the environment, small or large portions of open minds. Aside from expressing spirit through matter and using the senses as doors to the mind, the artist has another subversive talent: the ability to express maximum "content" by minimum means. He makes something out of nothing, or nearly nothing. The artist can be considered a brilliant economist.

I understand that a major reason why the art-appreciating part of society will tolerate and possibly admire the artist is that he can make a sheet of paper rise in value from a fraction of a cent to a million dollars. Since this neat trick is true materialistic magic, it earns the artist a place in society that is close to that of the quack who showed Rockefeller the black, all-purpose cure that turned out to be oil. The jester-artist is not only entertaining, he is economically useful; investment in him capitalizes quickly, provided the target for investment has been chosen carefully, whether by instinct or expert scrutiny. The right

kind of painting is a stock certificate that can increase its value much more rapidly than any other. The tickle of speculation in art exceeds that of horse betting in refinement and sophistication.

The artist catering to the tastes and expectations of the chosen few is a pitiable creature. Artists' obligations lie elsewhere. Villages, cities, regions, states, countries, continents have been turning ugly since the beginning of the Industrial Revolution. Planning of large change in the provisions for physical living has been left to architects with limited sensual imaginations. The architecture of the mind that is produced by "the media"—newspapers, radio, television—is the work of "professionals" with equally limited creative capacities. The artist-planner is needed. He can make a playground out of a heap of bent cans, he can make a park out of a desert, he can make a paradise out of a wasteland, if he accepts the challenge to do so.

It is obvious that traditional ways of planning or non-planning have proved disastrous. Harlem borders on the Upper East Side, and despite all the print and planning it is as horrifying as ever.

In order to enable artists of the future to engage in large-scale planning and shaping of tasks, art education has to change completely. At this point art schools are still training object-makers, who expect museums and collectors to buy their products. Art education has to point out first that the artist is not Alcibiades the elaborate wonder but

public property: his talent is owned by many just as a gardener's talent to grow flowers belongs to many.

The artist who designs environments on a large scale does not rule out other kinds of artists. He does not even rule out traditional forms of art. Dialectics of object versus phenomenon, of core things versus surrounding space, will continue, but borders have to open up completely and prejudices must be torn down. The feeling of guilt about planning for others has to be replaced by the pride of being an expert contributing things and ideas that others cannot contribute.

Elements and technology are the means that permit the revival of large-scale artistic activities. Wind may be considered the new siccative, while fire is a new gel. Technology permits the artist to talk to many, design for many, and execute plans for many. It's time now to do more than project: it's time to act.

The role of the artist in a reshaped society and a related new environment can be understood more clearly if we think of him not as an artist but merely as an expert economist of sensually perceptible means. Beauty can be understood as the accomplished highest economy of means. Aesthetics can be considered a set of economic principles. The beauty of a living environment stands for the economy of a living environment of health, comfort, and the balance of psychophysical powers. A freshly painted house is more likely to please its inhabitants than a house with a wrinkled and

greasy skin. A freshly painted apartment is more likely to make its inhabitants proud than a smoky, stained hole. A photograph that shows its subjects clearly and in vivid colors is more likely to make people feel that they belong together than a washed out, vague shot.

In addition to exercising his existence/moral-spiritual presence, a traditional role of the artist is caring about, and working on, the physical environment.

Another traditional role is education, with an emphasis on furthering everybody's creative talents.

A third role, also traditionally rooted, is preparing, maintaining, and regenerating occasions of pageantry.

Fourth role: performances in various arts and their coordination and integration.

A fifth and relatively new function is understanding the phenomena, rules, and aesthetic-sociological consequences of ecology--a dialectic exchange between man and his environment.

Sixth: rediscovering nature and the elements as a fund of forces that support man, that are not inexhaustible, that can be coordinated with the seemingly adverse effects of technology.

Seventh: bringing to the media as institutions desperately needed imaginative spirits. As a set of possibilities, the media have a chance for positive communication among billions of people.

Eighth: opening up and making habitable new spaces, such as the sky.

I am happy to concede that within and beside these categories there may be a little room for "art" and its habitual ways or the traditional hokus-pokus of an "art world." Ideally this art world will turn into a world of art where every- thing means something, in which there will be enlightenment of the artist, as well as of his audience, beyond becoming famous, beyond wielding power, beyond charming the mod masses.

Otto Piene

Part I
A Sample List of Things to Do, A–M

is of all classical elements the one that is the least ex-
plored by artists. It offers more new possibilities than
the other elements. Because of their light weight, works of
art that deal with air tend to be transient.

Air art

as it has been understood is a subdivision of sky art,
mainly displayed in interior spaces. Another word for air
art is pneumatic or inflatable art. It reveals some of the
potential of air but tends to settle in places like museums
and galleries.

in nearly any form can be considered flying sculptures
without independent aesthetic aspirations. The difference
between planes and flying sculptures ought to be one of
scale, subtlety, and variety. If a flying sculpture, manned
or unmanned, piloted or remotely controlled, tethered or
floating freely, outflies airplanes in one of these respects
it must be a cause for congratulation.

Airplanes can also be towtrucks for sky art.

Any art that deals with smoke, fire, vapors, gases ought to be beautiful without additionally polluting the already polluted atmosphere.

An important task for artists and artist-planners is to find elemental, sculptural, and ecologically responsive means of neutralizing pollution, especially in industrial areas, and of transforming what was threat into something useful or, ideally, delightful. For instance, colored vapors could be collected by huge transparent filterbags in the air, condensed and purified in liquid cooling systems, then led into the sea to reappear as "clean" fountains or colored currents.

Oil refineries at night are beautiful but stink. Maybe to "unstink" them would make them even more beautiful.

are used badly in the labyrinth of signs in the streets and
on the roads throughout the land. The pop horror of bill-
boards is worst in the U.S. One hint of how this offensive
situation could be turned into an asset is given when at
night you look at Los Angeles, Billboard City: huge il-
luminated billboards seem to float over the city. This ef-
fect could be easily obtained through the use of projec-
tions, especially when three-dimensional projections, holo-
grams, have improved.

For the rest, taste has to invade aesthetically criminal
corporations and chains like Howard Johnson and Holiday Inn.
Billboard aesthetics now exhibit economic waste and ruth-
lessness; in the future perhaps they will express economic
circumspection.

Aside from enriching the environment and enhancing the
spirit of its inhabitants, art as a subtle process in its
own right needs purposeless experimentation for the hell of
it or a l'art pour l'art department within the larger fabric
of art. Well-suited for large-scale experimentation, as
opposed to small-scale experimentation in the artist's
studio, are unused or widely unexplored areas like the
Antarctic. Forces of nature can be used as means and materi-
als; wind and water form "designed" mountains of snow, and
northern lights are led to shine upon them. Ice will be in-
duced rather than sculpted. Study Niagara Falls in winter.

Apparition

The struggle between object and appearance, fact and ex-
perience, picture and mirage, image and apparition will go
on and, I hope, favor apparitions over stable monuments.
Apparitions visible to many may be the large-scale artworks
of the future.

Love—hate between architects and artists often turns into hate—love. Let's assume that it will never be finally decided whether the chicken or the egg was first. I am in favor of thinking of the architect as the hen and the artist as the egg. Aside from that, the architect's profession and the artist's profession should converge again. Artists should forgive well—meaning German Bauräte for calling the artist's contribution "secondary architecture."

The architect's urge to build monuments to himself tends to overemphasize design and form and abuses architecture's function: to serve man. The artist, at least in his old—fashioned individualism, is often closer to his fellow citizens, because he is not running a weighted and weighing apparatus.

Planning, forming architecture, should start before designing it. Architects, artists, architect-planners, artist-planners, land-planners, ecologists, the community involved can get together before "building" starts. The purpose of creative activities is not to have more buildings or more art in the world for the sake of buildings or art but to have more people who enjoy being human.

The trend toward overwhelming man and nature by imposing massive concrete architecture upon them expresses the possessiveness of the architect-designer. It is a power-happy disregard of the human need for free space to breathe. Materialism and materiality in architecture seem to be coming to a climax. The kinetic and elemental artist may have something to say about changing patterns of human be-havior, needs, and reactions and much to suggest about flexibility, elasticity, adaptability, and audience parti-cipation in works and processes. If I. M. Pei permits me to let ivy grow all over his M.I.T. Earth Sciences build-ing, I will in exchange let him use some of my work as it suits his pleasure.

may be understood as a set of objects that are predetermined in kind; if so, the artist is an obsolete figure catering to the materialistic sense of man qua buyer. I see the role of the artist _de mon temps_ as one of providing information in varying forms, including one very pure "form," energy, and of providing a practical, justly shared, and worthy environment for his fellow men. The way artists are made and the way they work has led them to address the senses rather than pure intellect or pure physique and to use the refined senses as catalysts for the mind.

Art basically uses two kinds of scale, intimate and monumental. More attention should be paid to monumental scale—sky scale—in times when mankind proliferates and space expands and everybody realizes how large the cosmos is.

Art is neither evil nor decadent, although it is sometimes difficult to understand, and sometimes an effort is required to get acquainted with it. Art is something that not only Europeans practice but also American Indians. The lack of art, lack of interest in it, and contempt for it are serious reasons for the current crisis in the U.S.A. The blind hatred that the Nazis exhibited toward art, foreignness, nuanced poetry, and the avant-garde is comparable. The blood-and-soil attitude that art is something for women, the physically disabled, and the weak does not agree with the sophistication required by advanced technology. Art provides the means to understand oneself and the rest of the world intuitively and to act accordingly, to aim for a balance of body and soul and a harmony among men, nature, and technology.

Any artifact, however valued, however decorative, is irrelevant to society unless its message is sought after.

The aesthetic excellence of the hardware of the Apollo moon trips makes up for some of the flawed past of America as a culture. It is fair to ask whether the moon vehicles are or aren't art, whether they are sculpture or greater than sculpture. Like Lilienthal's gliders, they come close but do not carry concealed, codified, mysterious messages. They shine like Roman chariots.

The astronauts may gather experiences that are deeper, more dramatic, though possibly less refined than those provided by art. This is indicated by the cosmonaut Alexei Leonov's statement, "My First Steps in Space":

"Before me--blackness; an inky black sky studded with stars that glowed but did not twinkle: they seemed immobilized. Nor did the sun look the same as when seen from earth. It had no aureole or corona; it resembled a huge incandescent disk that seemed embedded in the velvet black of the sky of outer space. Space itself appeared as a bottomless pit. It will never be possible to see the cosmos in the same way on earth."

The artist works mainly for his audience and partly for himself. His work for himself is indirectly directed at an audience. One can interpret Goethe's <u>Weltflucht</u> and <u>Welt-sucht</u> as the forces that determine the artist's social position if <u>Welt</u> is people. The active artist and the passive audience are members of the consumer society in which the artist produces and the consumer receives. Audience participation in performances and cybernetic processes offers a solution if it is more than playing games and following instructions and if it is voluntary. The audience is as "good" as the artist.

If automobiles were sculptures and sculptures were automo-
biles, how much more fun life would have to offer. I prefer
racing cars to bad sculptures of racing cars by car-buff
artists. Aerodynamics can hardly be seriously concerned
since cars do not fly. Art in various media differs from
car races in that it does not kill or have the potential
to kill.

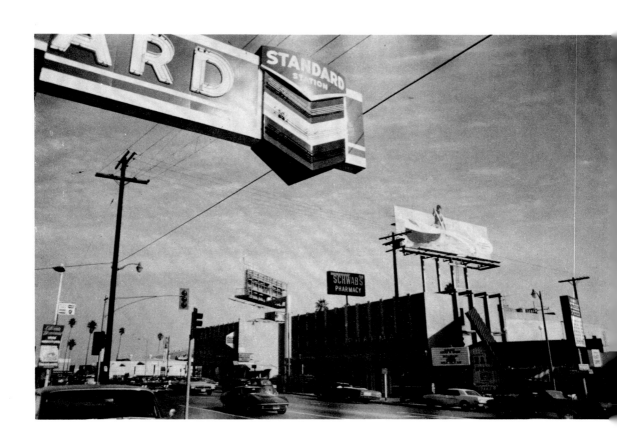

have an advantage over heavy bronze sculptures. Balloons are
light, can be handled easily, and can fly. The disadvantages
are also obvious: a balloon is breakable and short-lived.
Its being short-lived gives it grace and makes it a means
for direct communication as well as a symbol of the inten-
sity of the moment. Balloon sculptures are portable, fly
high, and fly far. The balloon as a marker is more feasible
than any solid sign or mast. Messages can be attached to it
easily. Balloons can make parks, buildings, cities, the sky
festive. When they have done their service, they leave
things the way they were--parks, buildings, cities, skies--
but they may have changed spirits.

Kinetic art has learned much from music. Light art has en-
hanced beat music. The integration of beat art with the
powers of traditional music has yet to come. Larger spaces
and open minds are needed.

Lack of a sense of beauty has made the United States into a land of waste and car dumps. Beauty is a necessary principle of sociopolitical reform.

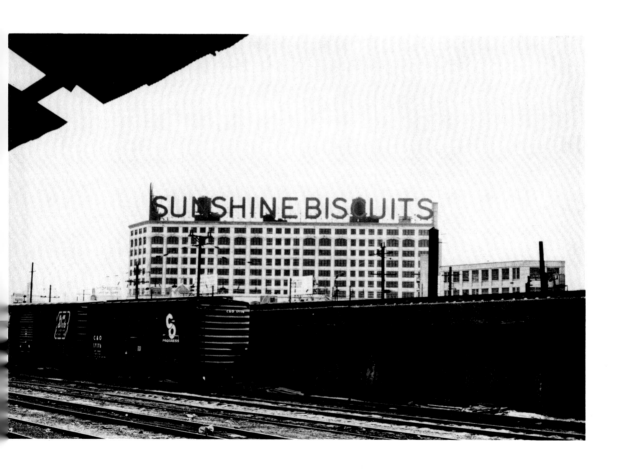

and the forces of growth enter the consciousness of artists.
Flowers, flowerbeds, parks, land, sea, sky are ecological
forms of organization on which urban bodies mainly have been
parasites. After cities have eaten up land for so long, it
is time for the green to eat its way into the cities. Lungs
of green will help the cities breathe again. If more animals
lived in cities, people could live there longer. The in-
sights of microbiology may help in the creation of growing,
edible sculptures.

The task of having to dispose of pigeon excrement by nourish-
ing the cities' flower beds seems to be easier than depol-
luting the cities' power plants. Bird-feeding islands in
cities, in the country, in the open sea will be living
sculptures.

Brooklyn Bridge and the Golden Gate Bridge show that bridges do not have to look gray-green.

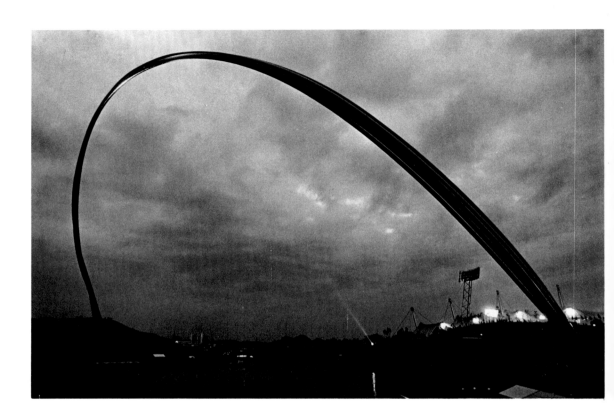

is not as bad as making billboards and advertising. The
architect's role in building has been understood to be that
of creating form. Form has been overrated and underrated at
the same time, overrated because many architects have for-
gotten the ants that are supposed to <u>live</u> in their fancy
piles. They have forgotten that people are supposed to use
buildings—that is why there are buildings.

On the other hand form has been underrated where profit and
industrial production are objectives. Processes of prefabri-
cation and of prefabricating building components are fre-
quently used as an excuse for forms that disregard human
emotion and the necessity of grace in everyday life.

The artist is trained to produce objects and environments
to human scale and to teach humans how to use their talents.
He can teach inhabitants of even bad buildings how to enrich
their apartments, make them warmer, make them habitable; he
can inspire his neighbors to build their own lamps, play
with their TV sets, hoist their own banners over their
houses.

To understand architecture as an anonymous club of experts
with rules that are little related to people is even more
dangerous than to consider the world of art as <u>huis clos</u>
because art does not build houses yet. In a democratic en-
vironment children have nearly as much of a right to like
Boston City Hall as bureaucrats do. I have not seen many
children who have a particular attraction to inanimate
concrete bunkers.

The least an architect can do is to inspire and liberate, from table-setting to bedroom refinement, the fantasy and imagination of people who have to live and work in precast apartments, offices, and factories. Currently the building establishment, designers as well as contractors and realtors/developers, does not allow much more. Artists are getting tired of being asked to design a plaque for one part of one wall at one particular turn of one hallway or one lobby because the architect or contractor "needs a little accent there" and wants to relieve his guilt about his ruthless profit-seeking methods and designs.

Often wall decorations and plaza accents, stone reliefs and sculpted fountains, obsolesce rapidly because they are merely fashionable. Chances for change can be provided easily. Some artists will enjoy serving functions, making sculptures that heat, providing light that makes plants grow, sculpting lighting so that it provides healthier illumination for working and walking and riding, indoors and out. An artist can be a designer. A designer ought to be an artist and not a profiteer.

Protest actions tend to become violent, for one reason, be-
cause their messages are often presented in a visually or
aurally ineffectual and unwitty way. The economy of protest
actions is frequently poor. Frequently it is as wasteful as
the economy that is being protested. An effective pageantry
of protest, a pageantry of constructive criticism, is needed.
One George Grosz is more economical than 100,000 screaming,
bomb-throwing Weathermen.

Beyond caricature and placards: the sky is the best canvas--
a bulletin board for worded constructive complaint: sky
writing, floating letters, vapor screens.

are monuments of misguided passion for academic tradition
(Yale) or academic status (Chicago Circle campus of the
University of Illinois). In America many campuses are un-
believably ugly, crimes of visual primitives against human
dignity and creativity or naive attempts to imitate Oxford
and Cambridge. Without greenery they would be totally suf-
focating. The only way to make them bearable appears to be
to cover them with foliage and enhance life through a more
imaginative academic pageantry. Can students (and profes-
sors?) design their own robes for graduation? Political
radicals in academic robes are among the dirtiest jokes
around.

Some new campuses, as Chicago Circle does, give the im-
pression that an academic 1984 is approaching fast. The
tightness of the designed system may really offer only one
chance for the expression of human life beside riots:
scribble on all the walls, windows, floors, and the expanses
of concrete. Use heavy caliber spray paint guns; then further
inundate the place with messages on paper. For temporary
relief, substitutes for the missing trees can be made out
of helium-inflated plastic and can be floated over the area
that is otherwise designed to death.

Sealing off campuses against a given community is an elitist
medieval idea. A school should have a spiritual existence,
not a poured concrete one.

If each building had a marking flag up on a high pole, orientation would be eased. Humble task: mark rooms, hallways, buildings so that purposes may be read quickly.

I don't understand college football, but I can think of something better; even jousting must have been more fascinating. The money spent and earned on college football can be better spent on neighborhood playgrounds and schools and universities for the American Indians.

I am not sure that I like the fact that the cupola of the capitol of Massachusetts is gilded. Is the Commonwealth wearing a golden hat? Gold seems to be something for shrines, not roofs and facades. A capitol is supposed to serve the people, not intimidate them. If the capitols amused, engaged, and surprised, they would better serve the people.

of formal events and informally linked experiences could
give us all-day, all-week theaters in space and time that
respond to distance, change of site, and change of environ-
mental conditions such as weather. A real space caravan
could be an intensified manifestation of space traveling
from star to star.

The airlines should give more consideration to making travel
on them a flight into events, indoors especially with the
747s, outdoors by at least offering passengers more pano-
ramic sensations. The interiors of airplanes are strangely
uniform. They offer vast possibilities for the sculptural,
environmental use of soft materials. The camel caravan of
the future is the space caravan. Let's make the price of
the tickets worthwhile.

Macy's parade is a first step toward a carnival in the air.
From carnival to puppet theater to theater to opera to huge
aerial performances are individual, logical steps. A theater
in the sky could be seen by many, children and adults. It
would also lend more convincing power to political theater,
more convincing than bombs.

Parades, carnivals—like other pageantry—are outlets for
creative imagination and activity otherwise suppressed.
Imagine the animals of Missouri in super balloon-size
towed in the sky over New Orleans.

can be thought of as sculptures that get us from one point
to another. Maybe the car can be inflated and serve as a
balloon to fly me; maybe it can float on the lake in which
I swim. Works of art ought to be more amphibious in any
case, and when portable electricity becomes stronger,
sculptures can fly to and rest on the Alps and look strange
there when the sun is rising or setting. So much for cars.

If one compares the ritual sports performances of the Don Cossacks with rodeos, rodeos would look crude. If every phase of the rodeo was photographed and the photographs blown up, they would look as dramatic as bullfights. No one who wants to watch a rodeo and does not carry a camera and does not get his pictures blown up to super life-size should be admitted.

in the United States have vandalized the environment. The
only exception I know is Wright's Wayfarer's Chapel.
Churches built during the past one hundred years are among
the ugliest things in the country. Kitsch is common in in-
terior spaces of worship even more than on the exterior.
The only solution for church kitsch may be a building ban
on churches for half a century. That would make churchmen
more inventive about site and liturgy. Ideally environments
and devotionalia might develop that are (1) not a plastic
imitation of European church tradition and (2) pure, vital,
and beautiful as gospel music. The purification of spaces
of worship is simpler for artists than designing a new
flower.

Aside from that, the idea of art as a domestic substitute
for religion and interest in higher values should be re-
examined. An Arp on the buffet does not necessarily make
the collector/possessor a better man.

It is not enough to decorate their plazas. It is not enough
to illuminate their parks in December. If building codes
can be created and enforced, color codes, material codes,
space codes can be developed at the risk of uniformity.
Space requirements imply that plants, trees, parks will be
kept alive and reexpanded in the cities.

Where there is public transportation, cars can be colorful
beyond advertising. Let school children paint them. Waiting
rooms in office buildings can be billboard environments so
nobody gets bored waiting. Constant showings of films and
other communications activities on civic subjects can take
place in public buildings. Parks, beautiful settings for
artistic events, should be partly heated in the winter so
that people can use them more comfortably. Large immaterial
symbols for the cities can spread over rivers and lakes and
be projected into the night sky.

The main objective of artistic plans for any city is to brir
out the local character, to make economic use of the given
(goods including garbage), to cause citizens to enjoy their
environment.

Much has been written about the design of signs and lights
in the cities by artists. Much has been written about their
role in creating parks and plazas. Artists may be able to
improve the comfort or lessen the discomfort of public
housing without increasing costs.

Some artists in every city must "lower themselves" to become
art/city planners, artists for the city. These art-planners
must be conscientious about the borders between planning and
mechanical manipulation. Artists might bring a little humor
to the sincere air of city planning. Something frivolous--
could we have Blue City and Spectral City?

Its worst enemy is uniformity. Now that we have an anti-
Brooks-Brothers generation, it depresses us with unintended
uniformity and unconscious practice of waste: jeans get
bleached and roughed up arbitrarily, stained deliberately.
Who is designing new, nonreactionary clothing using the
new materials to a surprising end? Maybe a drug is needed
that makes you remember that in the past there have been
many periods that produced fantastic clothes that were
neither dull nor Blut und Boden.

History of costume might be taught at universities instead
of ideology of primary structures.

The artist and the engineer, the scientist and the archi-
tect, the historian and the writer, the flyer and the sail-
or--such combinations of specialists can work together in
serving the community. The electronics engineer can show
the artist the tools so the artist can cast a thinker's
message into an audiovisual form that will be received by
television sets in Rome and New York and the moon. Art
schools, music conservatories, universities, and technical
institutes all should have their Collaboration Departments
or Integration Departments. The goal is intensified and ex-
panded communication. Artists may be able to conceive ways
for industries to get out of the vicious circle of producing
war materials.

In collaborative effort the artist offers intuition, imagi-
nation, shaping/expressing capacities, foresight.

by bodypainting may be a new way of dressing. Body paints
can be improved: bodypainting can be made a fine art. Stage
design can use painting on people instead of dressing them.

the sky so far has polluted the atmosphere. At night, light can produce clean colors. Artificial rain can create spec- tral phenomena in the sky during the daytime.

Apparitions are probably more healthful than the extensive use of whatever kind of material pigments. The age of the pigment appears to be an epoch in art that is coming to a close.

If there were no danger to plants or animals, it might be interesting to color a red river purple.

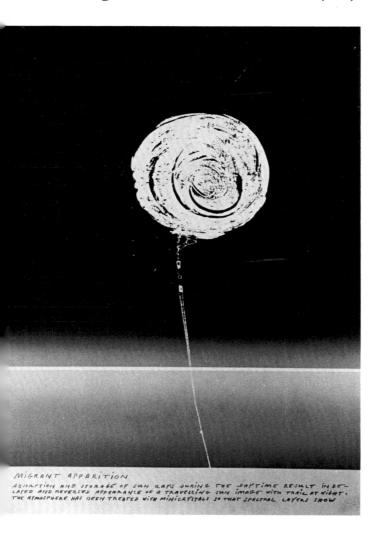

MIGRANT APPARITION
ABSORPTION AND STORAGE OF SUN RAYS DURING THE DAYTIME RESULT IN DE- LAYED AND REVERSED APPEARANCE OF A TRAVELLING SUN IMAGE WITH TRAIL AT NIGHT. THE ATMOSPHERE HAS BEEN TREATED WITH MINICRYSTALS SO THAT SPECTRAL LAYERS SHOW

Art and technology are good for each other and for the
public if they offer ways of understanding among humans.
The artist has to address an ever-growing public if he is
to help more people understand one another and the environ-
ment under peaceful circumstances.

Peace symbols alone, a pretty white dove on a blue button
or a black poster, will not suffice. Better television pro-
grams using the whole electronic alchemy are more important.
As wall-screen television and with it fully environmental
television emerge, television classes in art schools and
engineering schools are needed more desperately than paint-
ing classes.

What does the artist have to do with video-telephones?

Newspapers are ugly. They need new layouts.

Stereotypic magazines need new visual conceptions. <u>Playboy</u>
may need redesigned girls.

Community

The problem is not in replacing museum art with community art and not in replacing connoisseurs with <u>EVERYBODY</u>. The problem is how the experts in a society can be made available to, ideally, the whole society and how the artist can become "common" in this way without damaging his uncommon talent. The answer may be simple: to work for a city instead of for an elitist caste may, because it is an intrinsically more challenging task, therefore be one more suitable to the character of the artist. If he designs parks for a living area of one million population, his projecting imagination may be stimulated more fruitfully under public pressure. Though sometimes the artist's task may only be to determine which house to tear down and which to preserve.

for public projects, invited or open, can be offered to
artists as well as architects, planners, contractors. One
competition could be how to use garbage constructively.
Artists can make playgrounds out of car dumps and many
other kinds of junk.

Simon Rodia's Watts Towers are made mainly out of refuse,
and that is a strong argument for the artist's economic
power. Maybe Piero Manzoni's "artist's shit" statement was
not frivolous.

collaborate with writers and artists, and that is tradi-
tional. A new stage has been entered, as composers are be-
ginning to read drawings as scores and sculptures as musical
surfaces. Now composers, writers, and artists must work out
new spectaculars more powerful and also more peaceful than
gladiators' fights. They must include in these displays all
the traditional elements--air, fire, water, earth--but the
new elements too, technology and communication among humans,
that is, participation. The more interest in peaceful sensa-
tions, the less interest in war. The more interest in
guitars, the less interest in guns. Amplification permits
a composer to play his music for a whole city, a whole Sun-
day afternoon long, heard indoors and outdoors. Big Brother
music can be followed by communal silence.

Welcome computers. Do your own thing.

Currently there is so much concrete being used in architec-
ture that artists should concentrate on software—soft goods,
that is—and information through media. If, though, archi-
tects decide to pave more square miles of cities and campus
plazas in concrete, sculptors can be consulted to avoid
disaster.

is evidence that amusement parks deserve to be redesigned. On the other hand, artists can consider them marvelous examples of groupings of kinetic art, cybernetic art, conceptual art. Design a carousel that out-carousels existing carousels.

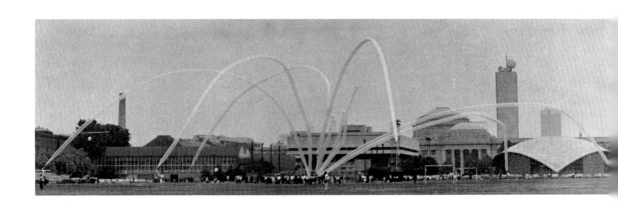

is one of the leading styles of modern art, and it is worn
out like other such styles. The search for style can be
replaced by a search for purpose and practicality. Consider-
ing that stylistic considerations have been exaggerated for
two hundred years, it may not hurt if function is now paid
"too much" attention. Sculptures that light or heat recrea-
tion areas may not only be more useful but also more beauti-
ful than petrified reclining women on pedestals.

The outcry against conventions has become conventional. New
conventions are replacing old conventions, and the only
response is to keep on replacing. Theater turns into theater
in the nude. Maybe the audience should be nude for a change.

While it used to be a convention that the artist should be
trained to draw nudes, a new convention could be that he
learn parachute-jumping and pyrotechnics.

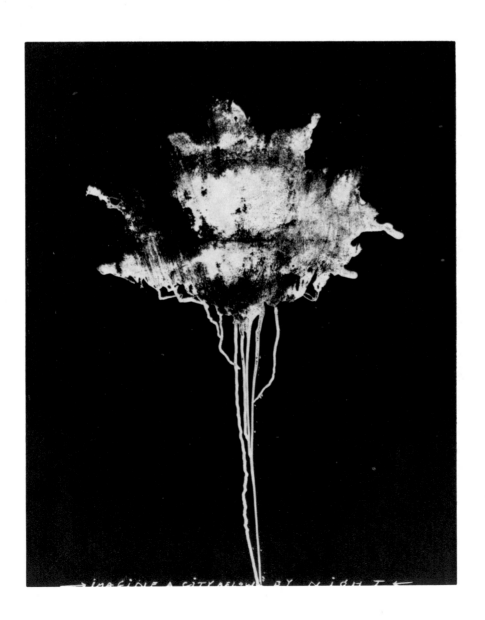

The grand ceremonial magic of royalistic state affairs,
during which everybody watches passively and everybody feels
inferior, can be changed into community festivals in which
everyone sends his own flowers, kites, birds aloft, which
will in turn form an oscillating pyramid of motion over the
area, a ballet of goods and animals.

The body of the community needs a rich pageantry that unites
its members more closely than watching Johnny Carson.

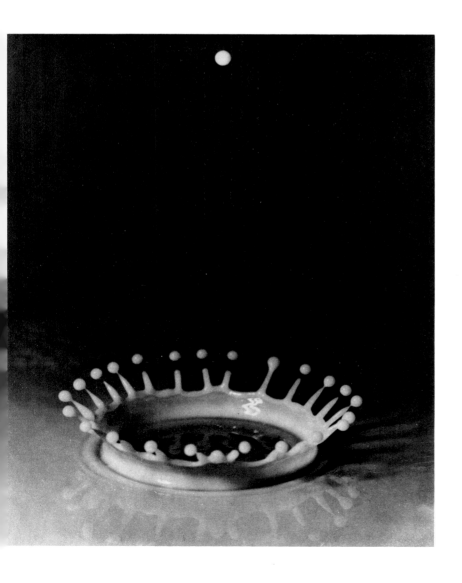

regardless of whether they belong to the military-industrial complex, are composed of profit-seeking individuals or groups. Corporations have a tendency to place their welfare above that of people or environment. One artist or a group of artist-planners for each corporation in proportion to its size might mellow the negative impact that many corporations have on social organisms. I am not merely calling for the emergence of the artist-conservationist; ideally, I mean that the artist, along with conscientious scientists, should turn Elizabeth, N.J. into a less suffocating environment.

can be made superfluous by better nutrition. Facial painting
can be more fun than painting on canvas.

and astronauts may be the only people in the world who wear clothes born of our own age. Their launch and return is initiating a new form of pageantry (think of the color-marked crews on aircraft carriers, the colors of smoke-markers, the hues of helicopters) that bears resemblance to medieval ceremonies, the departure and return of crusaders and knights in their heraldic apparel. The TV-provided intimacy with moon-trippers opens a new dimension of indirect/direct experience/exposure.

Jesus, another "creative"....

Creative Advertisements Inc 120E56 .. 753-4174
Creative Advtg Promotions Co 38W32 .. 564-6065
Creative Agncy Inc 295MadAv 889-4600
Creative Aids Inc 6Chrch WOrth 4-3950
Creative Art Cntr 1442 3Av 249-9704
Creative Art Flowers Inc 915Bway 533-3650
Creative Art Lighting Corp lmps
 256GeogaAv Bklyn HYcnth 5-8720
Creative Art Prntng Co 106E19 .. GRamrcy 7-1392
Creative Art Statnry Co 520W36 LO 3-7948
Creative Artists 250W57 765-1888
Creative Arts Rehabilitation Cntr Inc
 18W74. 724-0500
CREATIVE BINDRY INC 215E22 .. 679-5533
Creative Campaign Analysts 303W42 .. CI 6-5300
Creative Capital Managemt 330MadAv .. 682-2085
Creative Careers Only 527MadAv 688-2810
Creative Carpt Co 113E29 679-5457
Creative Castg Consultants Inc 16W16 .. 924-3322
CREATIVE CELL 430E56 355-6858
Creative Cntr Inc 29E61 838-1542
CREATIVE CHARTISTS DIV OF CREATIVE
UTILITY SVCES INC 88Reade 267-3981
Creative Collateral Materials Inc
 1010Hope SpringdaleConn NYC# 597-2134
CREATIVE COLOR INC 25W45......JU 2-3841
Creative Concepts dsgnrs 123E54 753-0241
Creative Containers Corp
 175CentralAv PassaicNJ NYC# LO 3-3684
Creative Copy Assocs 527LexAv...... 421-2365
Creative Crafts Corp 46E11 OR 4-3783
Creative Custom Labs 37E28 532-7870
Creative Cut Beauty Salon
 1464StNchlasAv. 781-9420
Creative Decor 77Bleekr 477-6780
Creative Designs Internatl 1RivrdlAv Bx .. KI 9-4545
Creative Dimensional Prods Corp 4W40 .. 524-2161
Creative Displays Inc 1270Bway 565-0612
Creative Drapery 524W43 LA 4-6290
CREATIVE EAST INC 150E19 AL 4-8776
Creative Embroidery Co 99Sprng WA 5-6822
Creative Enamel 50W47 246-9661
Creative Engnrng Co 88Reade 267-3981
Creative Fabrics Inc 991 6Av PE 6-4253
Creative Features Inc 19E53 PL 5-6131
Creative Film Assocs Inc 127W96 AC 2-7006
 Scrng&Editing Rms 723 7Av 246-3030
Creative Finishes 306E5° TEmpltn 2-8570
Creative Food Svce Inc 300E46 YU 6-5140
Creative Furs 242W30 LOngacr 4-8559
Creative Galry 36W57 245-7370
Creative Graphic Svce Inc 119W23 . YUkon 9-0298
Creative Group Inc The 432ParkAvS 684-5560
Creative Handbags Inc 1204Bway...... MU 6-4790
Creative Hobbies 71W23 242-2993
Creative House Imprts OldWindyBush&
Aquetong Rds NewHopePa 215 862-5604
 If No Answer PhiladelphiaPa 215 794-7012
Creative Hse Inc 21E40 532-5250
CREATIVE IMAGES 115W71 SU 7-2626
Creative Images Ltd 200W57 586-1627
Creative Imprts Inc 6E39 MU 3-0522
Creative Internatl Inc 132Nasau 925-5720
Creative Internatl Inc 156W44 247-7377
Creative Investor Svces Inc 550 5Av ... PL 7-3638

Creative Lamp Co 304E54 MU 8-3520
CREATIVE LEASING CORP 216E49 ..421-0770
Creative Leather Goods 64Fultn 964-3988
Creative Lithography Inc 207W25 CH 2-6257
Creative Looms Inc fbcs 231E51 MU 8-2863
Creative Mailing Svce Inc
 1100StewrtAv GrdnCty 516 ED 3-8100
Creative Managemt Assocs Ltd 555MadAv 688-2020
Creative Marketing Co 400ParkAv 752-4195
Creative Mdsng 160Varik YU 9-7380
Creative Metal Prods Inc fcty
 68Fleet JerseyCityNJ. NYC# WO 2-1290
Creative Money Managemt 315 5Av ... MU 4-3590
Creative Monograms Inc rwlrs 83Canal. CA 6-7864
Creative Motion Picture Corp 550 5Av .. PL 7-6454
Creative Opticals Inc 35W45 JU 2-3020
CREATIVE PACKAGING INC 330MadAv 867-2850
Creative Paintg&Decratg Co
 20EKngsbrdgRd FOrdhm 4-2000
CREATIVE PERFUMERS & FLAVORISTS
INC prfums 636Bway 254-0118
Creative Placement Agncy 120E56 752-7623
CREATIVE PLAYTHINGS INC—
 Retail Store 1RokfelrPlz JU 2-6699
Exec&Buying Office
 EdinburgRd CranburyNJ NYC# WA 5-5311
Creative Polyproducts Co 42Bond AL 4-3037
Creative Press 749 2Av MU 7-7381
Creative Process Corp colr separations
 64W22. CH 2-1015
Creative&Productive Ideas Inc 50Bway 943-5517
CREATIVE PROGRAMS CORP
 295MadAv 889-4600
Creative Projects Inc 10E40 LE 2-7560
Creative Promotions 341MadAv 684-4896
Creative Research Designs 1RokfelrPlz .. JU 6-7327
Creative Research Svces Inc 220 5Av .. MU 6-6997
Creative Sampling CoInc 33Bleekr 228-0550
Creative Scope Inc 1E42 687-2570
Creative Screen Prntrs 42Bond AL 4-3037
Creative Svces 1133Bway CH 3-6071
Creative Signs&Displays Inc 866UNPlz. 751-6320
Creative Steel Rule Die Co 24Wostr WOrth 6-4650
Creative Studio frat supls 175 5Av .. GR 5-1399
CREATIVE SURFACES INC 175 5Av ..475-0630
Creative Systms Inc
 2079WntaghAv Wntagh 516 826-3325
Creative Texstyle Inc 2875Bway OR 5-4257
Creative Textiles Inc crpts 295 5Av .. MU 5-5920
Creative Therapy Cntr 88-45 163 Jam .. 523-1913
Creative Tour Operators Assn Inc
 777 3Av. 758-2011
Creative Travl Svce 445ParkAv 421-7272
Creative Trust The 550 5Av PL 7-3638
Creative Type Composition Svce The
 150 5Av. 691-7000
Creative Utility Svces Inc 88Reade 267-3981
Creative Ventures Corp 866UNPlz 752-7060
Creative Visual Media Inc 138E36 MU 5-8236
Creative Visuals 137E36 686-3170
Creative Workshop Inc art 137 1Av. ... 988-5100
Creativision Inc 1780Bway CI 5-4830
Creativity Unlimited Film Prodctns
 1379LexAv. 876-7654

The two main functions of art vis-à-vis society are being critical of the present by simply analyzing it and mirroring it and, more important as I see it, suggesting constructive change. Critical art has benefited a great deal from new techniques of reportage like photography, film, television. The artist's intuitive understanding of his time is needed as a basis for positive reform. Film is more important to art students now than watercolors.

If I want to see what it looks like when a hydrogen-inflated plastic hose burns and explodes, I must go to a place where this experiment will not hurt anybody; but the experiment as such is necessary to turn a thought into an experience.
Almost all art forms are still more sensual than cerebral.

Art has always functioned as a dialogue among artist, art
object, and observer. It is a democratic act if the artist
gives the observer/participant a greater choice and span for
action and reaction. The idea is not to make the artist lazy
and the participant diligent but to direct and redefine the
dialogue between the artist and his audience for the benefit
of their mutual experience and their mutual environment,
possibly at the cost of the independent object that was
formerly regarded as the sole product of the artist's acti-
vities.

Aside from events, performances, and cybernetic environments,
public issues can be made into participatory challenges if
they are laid out so that the public can express its views
and choices in three-dimensional, drawn, tape-recorded,
televised form. Moholy-Nagy's distinction between Gesamtwerk
and Gesamtkunstwerk is relevant here: artist and audience
join forces to create their Gesamtwerk, their lives and
environments.

Having tried to make dancers and moving things and appear-
ances interact, I am now curious about how human dancers
might interact with huge, artificial, inflated, mobile dan-
cers. Such performances might be anywhere--indoors, in a
factory, a barn, a city hall. More interesting: an aerial
ballet.

Now the artist can add moving parts, sculptural and pro-
jected, inserted into the air by his design and produced by
a participating audience. Indoor interplay among dancer,
artist, and viewer would of course produce a new range of
variety, but a change of scale would be brought about by a
sky dance employing flying vehicles and possibly huge puppets
and projections formed by immaterial or near-immaterial
means.

Materials used for traditional dance performances--Chinese
or Russian, for example--are worth consideration for use in
new, large-scale soft sculptures and props.

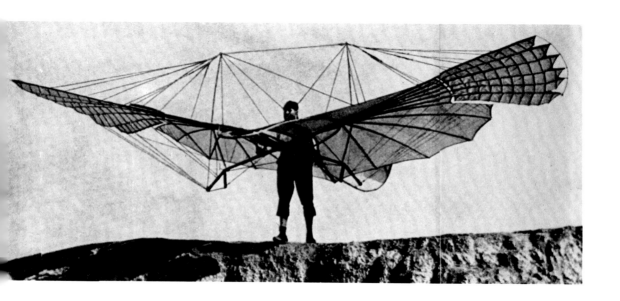

sculptures moved rhythmically by rain and wind reveal the rhythms of nature. Weather tears apart wind-sock sculptures after a while, but before they vanish we have had a chance to understand a form of grace.

in the United States has intents and purposes best explained
as the artist's effort to make everything look and work as
well as American plumbing. I have mentioned already that the
possibilities of design go nearly as far as redesigning
girls. Therefore the average designer sometimes views him-
self as a worldly demiurge. Let's remember that spirit pre-
cedes "creation."

Five years ago it was encouraging to watch how quickly discotheques responded to the influence of light art. Now they have worn out their adaptations. Random projections are boring already. Discotheques need a shot in the arm in the form of tighter timing and coordination of sight, sound, haptics.

in art is using both natural and man-generated forces, the materials and human energy of a given environment, in order to enhance life in a given environment and possibly beyond those geographic borders. A town that produces much scrap metal can have playgrounds made of scrap metal, or, more to the point, an artist-planner can try to counterbalance the scrap metal by increasing the number of flowers, trees, shrubs, and birds in town.

Ideally an artist who has investigated the ecology of his region, state, or country will try to use the polluting smoke billowing out of imposing stacks of steel mills to make beautiful sky-smoke sculptures that act as filters and in the end leave the air clean and healthful.

Art can be interpreted as a set of empirically developed rules composing what may be called applied intuitive economics. One slice of these rules is usually referred to as functionalism.

Good plumbing is well-functioning plumbing, and the excellence of its function is a result of good design. Nobody expects plumbing with frills, and everybody thinks U.S. plumbing is good. U.S. cars consist mainly of frills tacked around good motors, and the general notion among designers is that U.S. cars are bad.

The artist's task has always been to bring materials, techniques, and contents/ideas up to their best potential. The more those potentials of force and materials are exhausted, the more intense, the "better," and also the more economic is the work of art. If we extend the rules of art/economy to the environment, we can consider a city a large canvas on which to paint economically, according to the rules inherent in art.

The conscientious artist can tell where materials or human forces are wasted and, one hopes, how they can work economically, that is, preserve and enhance life.

are logical candidates for sponsoring light monuments for cities, airports, harbors, and other significant points in the country, just as the aircraft and aerospace industries are logical sponsors for "flying landmarks."

Manufacturers of electrical equipment are virtually the new foundries for light sculptures. I am working on large-filament bulb sculptures as unique objects: serialized, medium-sized filament sculptures for logical mass-fabricated multiples, projecting bulbs with elaborately shaped filaments for pinhole projections (light ballet).

Electric appliance companies ought to have to listen to thei TV ads for Louis Quinze television chests until they become sick, giggle, blush, and give up their nonsense lines. Even more responsibility will rest with them when the wall-to-wall, floor-to-ceiling, total TV environment is a part of everybody's home.

The role of electricity in keeping our bodies and souls connected is being revealed increasingly. Perhaps in the future we will be able to render visible man's individual electric radiation, thereby making another image of the Bible real: the halo.

like the electricity that we pluck from the invisible, can
be understood as an experiential process of revealing hither-
to inaudible sounds. Amplified micro-sounds are part of the
music of our time.

In efforts to integrate the visible and the audible, visual
art must generate sounds and music, and vice versa; neither
is merely to illustrate or accompany the other.

There is no such thing as <u>l'art pour l'art</u>, unless one wants
to allow art to remain a toy for the idle. Look what happens
to Morris Louis's art when it becomes a school—and Larry
Aldrich writes about it!

When drained of nature in the process of its evolution,
modern art became decorative, and with Kandinsky, Max Bill,
or Noland/Stella/Olitsky/Krushenik, a matter of entertain-
ment.

The first element to be added for greater vitality has been
technology. Now that we are in a position—free enough—to
approach the elements with art "obstacles" that bring them
out, let them point at themselves, and thereby reestablish
a rapport among nature, the modern made environment, and
latter-day man. A wind-sock sculpture tells us more about
the weather than a Brancusi; also, wind is cheaper than
bronze. If we start from here and keep the research into
ourselves and our environment going, we will not have to
worry about durability of works of art, because our dialogue
with the elements will proceed, refreshing and replacing.
My rapport with nature is more important to me than my
possessions.

So far much of the collaboration between art and engineering
has been restricted to the mechanical area of that science.
Kinetic art as an art of movement within the object, or as
an art of the moving object, is a poor thing. The Denise
Rene Gallery appears mainly to be a shop for kinetic con-
fections of this kind.

As engineering has evolved into a means of mastering scale--
for instance, long distances--engineering in art should
serve as a vehicle for mastering large-scale art, art that
travels far and reaches many.

Aircraft engineering can launch the artist's message into th
sky canvas. Electronic engineering can telecast the formerly
bronze-cast creation. Computers can proliferate poetry.
Pneumatic architectural engineering can provide a shelter
for life analogous to an art of events.

Brighter light art might mean further enlightenment--beyond Grünewald's "Resurrection." The seemingly solid laser beam points at a world of existing immaterial objects. We are close to electric angels.

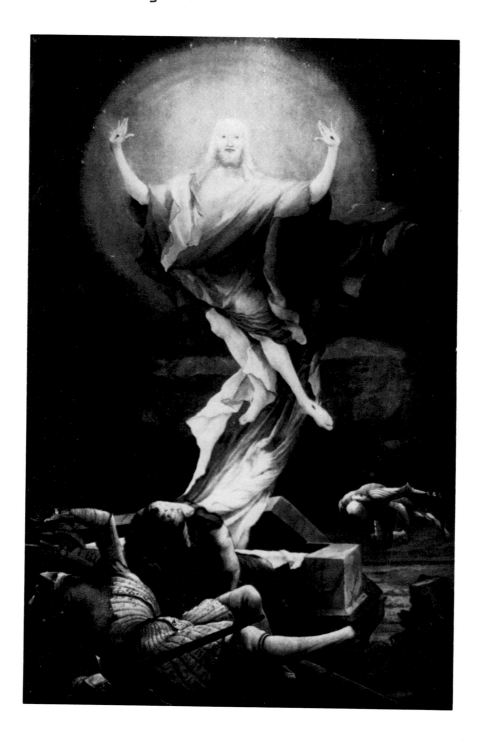

Although the moon trips have given simple empirical evidence
of the physical nature of the solar system, we may still
think of ourselves as living below the firmament of heaven,
within the shell of the sky. If we agree that living in a
shell means that we do not have to build thick shields over
ourselves, we could settle for flexible, transparent skins.

So far, creating an environment—a house or a town—has
meant pushing a positive shape into the passive atmosphere.
Inside the positive shapes of skyscrapers and log cabins
there is hollow nutshell space for living. Can we hook veils
onto the sky and live in open spaces under them, spaces that
permit us to exist freely so that we do not have to fold our
selves up and crawl backward like the hermit crab when we
want to go "indoors"? Instead of creating positive objects
that fill existing spaces, the artist can create or define
large open spaces according to his need for them. Space is
space for living. We do not articulate space by filling it
with huge concrete buildings that suffocate us, leaving us
only the interstices for breathing.

How healthy it would be if we had Niagara Falls instead of
Rockefeller Plaza.
A most dramatic environmental event: the 1965 New York
blackout. Imagine if, when light returned, it had been blue

There is an art world and a world of art. The former inclines toward nineteenth-century social patterns and looks increasingly like another form of show business, a large machinery of presentation that disregards content and meaning. It grinds away as long as the mechanics enjoy watching it run and as long as they feel they are running it--although it largely runs them, in fact.

The established art world institutions, particularly museums, are geared to the art world as it developed out of the French Revolution and the emancipation of art from its ties to other fields. Now along with the bourgeoisie there go its institutions; the museum as a treasury of possessions is saturated with goods and fails to perform a vital function that goes beyond preserving values of the past.

Museums and art dealers that do not turn into agents, in the sense of chemical agents that build new structures, will soon become useless to artists and a young, growing audience.

The world of art is constituted by artist-citizens and virtually the whole rest of the world. The artist supplies information, possibly in the form of pure energy, and helps to provide a humane environment. In his case neither money nor power are considered goals; if anything, they may be means to further the exchange of communication: better instruments may play better music.

Luckily artists are becoming aware of the fact that funcionaries exist to perform useful <u>functions</u> for art despite

the illusion that some functionaries seem to adhere to, namely, that artists are cannon fodder in their battles for power.

Verbally articulate artists, fortunately, can make the establishment, the have-moneys as well as the have-powers, feel miserable.

of long term, events in the form of staged, slow, natural
processes, are conceivable, but one advantage of most events
over lasting installations is their short lives. A thin-
skinned flying sculpture is short-lived because the rapid
changes of shape it undergoes produce heavy wear and tear.
Rapid change permits a string of experiences for a single
spectator. He himself changes position, mood, degree of
consciousness, as the event proceeds. The event structure
permits an exchange of experiences between artist and
viewer, not possessions. The event as a work of art—as
process art—is largely antimaterialistic.

The monument of Vicomte de Lesseps changes only if you
blast it.

understood as event, does not have to be a dead word and a
worn-out procedure. What's worn-out are the traditional lo-
cations. Ships, city halls, mines, TV stations, the sea, for-
ests, farms, dairies, factories, homes, islands, airplanes,
the sky, and the moon seem to be better suited for exhibi-
tions than most galleries and museums. The latter were built
to house paintings and still sculptures. That's not enough.
Like zoos they present only samples, not living organisms.

aside from being fun, offer a treasury of ideas to artists
with limited powers of imagination. I suggest that shooting
galleries be replaced by bubble halls challenging people to
produce the largest bubble ever. Prize-winning bubbles could
be hardened, then made into polarizing spheres and used for
music kraals.

Simulators of flying experiences have always been a major
part of the Palisades Park. In the future they will probably
shoot people up instead of dumping them down.

I can think of many places where fairs might be located; on
my imaginary list military sites have urgent priority.

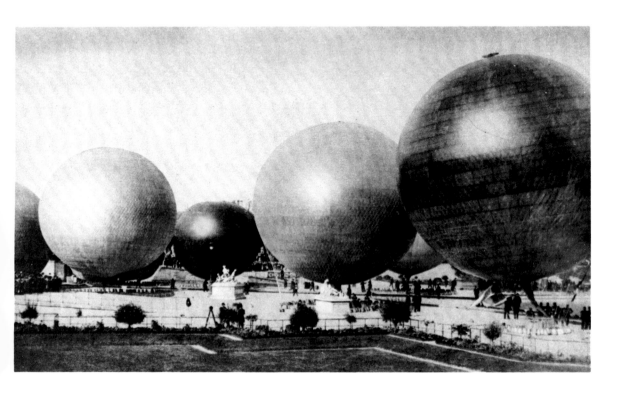

At one point I discussed with Harold Tovish and then others
at the Center for Advanced Visual Studies at M.I.T. the plan
for a Charles River Light Festival that would later become a
Boston, then Massachusetts, then U.S.A., then World, Light
Festival. Aside from staged large-light spectaculars, addi-
tional possibilities are electric-bulb rallies, single-color
home lighting for certain hours, one-color street lighting,
simultaneous switching on of the headlights of all automo-
biles, and an aerial ballet performed by a swarm of light-
bearing helicopters.

Light being the life force sine qua non, and light festivals
having a colorful historical and religious background, it
would not be terribly difficult to sell this idea. Light
corporations might find themselves in the same camp with
pyromaniacs, pyrotechnicians, and candle-makers.

after leaping during the first decades of its history, is
now limping. We are waiting for all-walls-screened film
theater.

Our interest in fugitive phenomena and effects on the en-
vironment makes fire an appealing medium. It shines, warms,
reacts strongly to other elements, and retains power even
when confronted with massive technology. To master fire is
an old challenge to man.

Fire as a medium has always been an expression of man's fire
dance between destruction, survival, and hope. A fire foun-
tain, fire-lined play area or tall fire monument may be more
strongly affective than a fire painting.

Can accumulations of exhaust gases from petroleum refineries
be collected to feed one large single flame? Philadelphia
might want it.

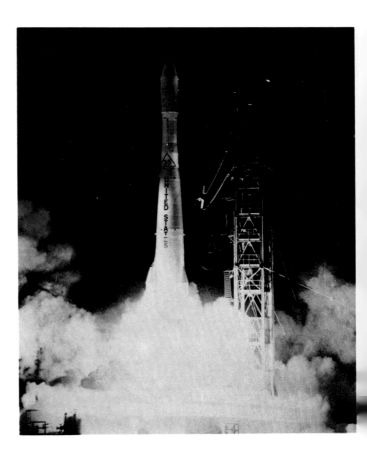

Fireworks

are an old form of the peaceful use of destructive technology. I still think that this principle could be applied in the far reaches of space in order to get rid of the world's atom bombs. Cosmic fireworks and artificial northern lights may move traveling salesmen as they journey between planets.

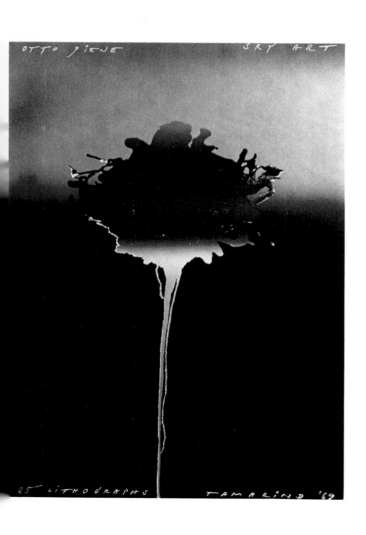

Fish

Swimming works of art that are manned and equipped to re-
ceive any messages from networks the world over may also
respond to sonar vibrations from porpoises and dolphins.
Water sculptures that grow like algae can be used as bases
for surface sculptures.

Neon fish are at once so delicate and magnificent that they
keep the artist from becoming complacent about his own work.

can hold flags, banners, ribbons, fish kites, wind-socks, wind puppets, and combinations thereof--wind sculptures for good and bad weather.

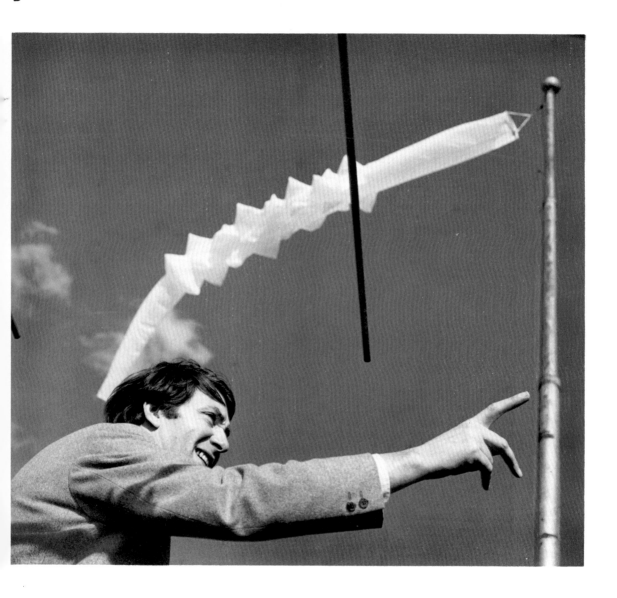

give pause for thought about whether slate or cloth is the
more interesting material for sculpture. On the other hand
I wonder why conventions about them have been so narrow for
so long. Swiss peasants brandishing flags and Russian and
Chinese dancing with silk banners make good use of their
fabrics.

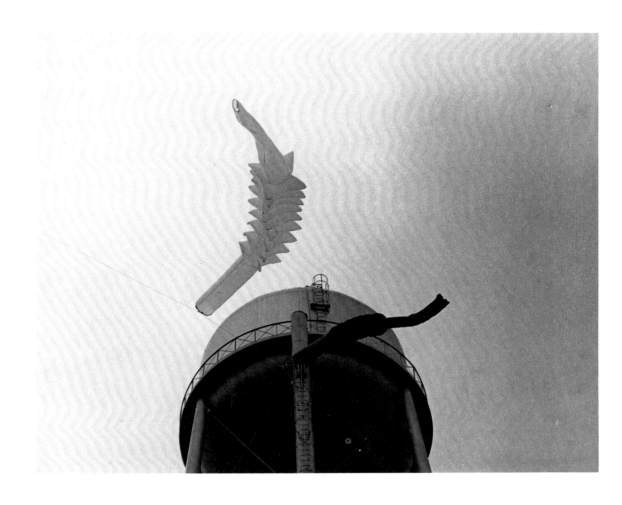

is man's only essential accomplishment since Egypt. Art that does not fly itself and does not make man fly better is not on a level with this new essence of life. As a consequence of man's ability to fly, one part of mankind will eventually leave the earth like the emigrants who crossed the Atlantic to go to America.

The aesthetics of flight have been understood from the beginning, along with the aesthetics of flying tools. The spacecraft industry presents vehicles of plain technological beauty. They are not art, though, because they have no built-in capacities to reveal themselves beyond their functions.

do not think it is by accident that we are told repeatedly that soaring and parachuting come closest to art experiences.

Flowers

as we learn from Antonio Gaudi, can be inspiring to stone
architecture. When I look at a Mondrian, I think of the
landscapes that he painted semisecretly along with his rec-
tangles and squares. There has been a lack of flowers in our
environment, especially the industrial-architectural en-
vironment. New sculptural and building techniques allow for
flowers much more floral than Gaudi's. The pneumatic baroque
will proliferate, and we shall have soft giant flowers in
the sky, useful and not.

A bat ballet, natural and artificial, in the sky. Bird sculptures--feeding stations not only in the water but also on huge masts.

Aside from gas-inflated floating letters of many sizes and
configurations and aside from the biblical flame letters,
close-up and remote, over the sea and the desert, there will
be projected letters and floating messages. Space flyers
abandoning their ships will leave orbiting messages as
sailors left bottled messages in the sea.

All these messages, political or poetic, or both in one, I
hope, are not to clutter the cosmos as billboards have
cluttered California. Many flying messages are temporary
by nature.

are among the oldest things. It is only a small and natural
step from water to fire to gas to air to electric, that is,
magnetic and sound, fountains. There can hardly be too many
fountains, public and private, all of them focuses of social
and spiritual life, usually by means of measured physicality.

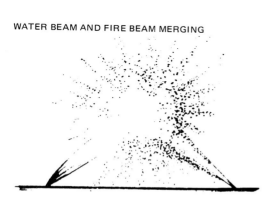

WATER BEAM AND FIRE BEAM MERGING

"HIRAM AND THE QUEEN OF SHEBA"
WATER AND FIRE FOUNTAINS COLLIDING

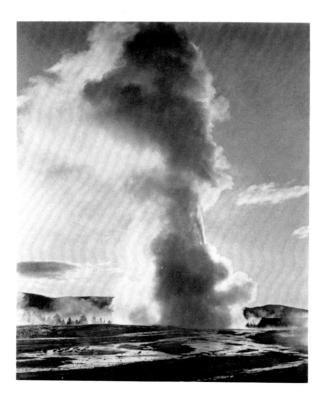

As to most objects of art, beautiful by the dicta of the art
world, useless by standards of the materialistic world, it
would certainly be good if they could be forgotten and re-
placed by an art that serves a function not only for a con-
ventionally intellectual life but also for a life that is
determined by the sensibility of physique.

Heated sculptures in homes, heated trees in parks, the
sculptural realization of air conditioning, sculptural so-
lutions to other engineering problems, the design of lighting
as an expression of the plastic values of light as a medium--
these examples for an initial turn toward functional art are
a tip of the tip of the iceberg of possibilities.

A one-sided interpretation of the term: a gallery is a shop
in which the merchandise is manufactured by artists. Equally
nasty: an art dealer is a shopkeeper who sells merchandise
manufactured by artists.

The rigid make-buy-sell system, itself a reflection of the
artist-dealer-public system, does not really work in a world
in which the artist is a designer of environments, events,
and processes. The advanced dealer has become or will become
an agent, spotting opportunities and channeling and organ-
izing the artist's activities. Although the over-the-counter
business in the art world will not decline rapidly, the
dealer-agent is more encouraging to the artist already than
the hardware salesman.

The imaginative dealer will not only protect his own inter-
ests but also the artist's. He should see how compatible
they are with public interests.

The gallery as a haven for individual shows still offers a
modest challenge to the artist because he can show there his
purely experimental, intimately scaled work. Fortunately,
the run for prestige among the galleries is on the decline;
the Alcibiades contest becomes less interesting when the
artist leaves his ivory tower.

For the time being most galleries would benefit themselves,
their artists, and the general public if they were more con-
cerned with the hardware of architecture and multiples and
the software of processes and planning.

A rightly favorite idea of artists, architects, and ecolo-
gists is to use garbage for building material after the
garbage has been processed, that is, hardened, softened,
molded, or simply poured into prepared spaces or containers.
Dada, junk art, funk art, Arman, Mark di Suvero, and above
all, Simon Rodia give us initial hints at chances to use
waste well.

Many of the reconstructed towns and cities in Germany re-
flect over-planning by building administrations. The uni-
formity, mediocrity, impersonality of much of the architec-
tural hardware does not leave enough room for change toward
a functional baroque of the portable, mutable environment as
a work in progress. Germany's best architect, Frei Otto, has
not built much in his country.

I do not see why a large city or small village could not be
like a forest of elastic trees with signal leaves, rather
than like an Egyptian graveyard with traffic lights and
air buses.

Artists have no lobby to ingratiate them with government. Indeed, they are unlikely to have any connections with the government whatsoever unless they kowtow before individual leaders.

The artist as economist as well as the artist as an individual who receives and interprets the signals of the <u>Zeitgeist</u> could prevent governments from making mistakes. Had governments taken Picasso seriously in the thirties, World War II might not have taken place.

Artists are aware of their visionary talents. But they must be willing to apply them to practical problems, such as our political situation. Inevitably they have to ask for art power, a voice in the matters they understand: beauty, health, economy, or all of these.

Any political leader who surrounds himself with kitsch of any sort, political, religious, or aesthetic, is to be mistrusted.

are many people's poetic outlet, political panel, psycho-
logical release. In any community of whatever size graffiti
boards are needed where people can scribble and smear openly
and secretly.

are still useful to express ideas, feelings, and fantasies straight from people's heads. As graphics are generally low-priced and editions today increase in size because of advanced printing technology, graphics make trade easy between the artist and his public.

Chances for better political posters are enormous, because the posters at present are generally childishly simple-minded. Posters do not have to fall back upon brutal Nazi propaganda tricks. The artist does not want to manipulate half-truths visually.

I feel a rainbow is a better peace symbol than a dove, as doves tend to be drawn in black and white.

The sense of poetry and the sense of the absurd that the artist has to maintain.

Despite the importance of social commitment, the artist must retain a minimum degree of mental independence by hook or by crook. That may sound ambiguous, may be interpreted as an indication of the half-heartedness of my own commitment, may be regarded as simply impossible. Yet one perennial source of inspiration to the artist is his sense of humor based on the comical, the absurdities of life, something I miss in Victor Vasarely, Nicolas Schoeffer and Waczeslav Richter, while I feel it is apparent in Calder, Fontana, Picasso. I have always thought it sad that Mondrian had Neo-Plasticism in his front room and pornography in the back. Green-toad jelly can glue together opposites.

My experience with groups is extensive. Strange as it may sound, my most positive experience with groups has been with Group Zero in Germany. Although it collapsed eventually and, I feel, partly did so without my approval, it did work successfully for nearly ten years.

As I have explained before, the key to Zero's success seems to have been the voluntary commitment of its links--individual artists--to voluntarily shared ideas. More rigidly organized European groups of the late fifties and of the sixties disintegrated much more quickly. Strict regulations turned out to be too narrow to sustain common interest.

In this country the idea of groups has raised artists' suspicions. Only recently have there been groups resulting from the necessity of teamwork on complex projects such as electronic media shows.

Only if large-scale projects that serve communities arise from social needs can artists in this country be assembled to serve common causes. Until that point is reached, groups will be suspected to be associations of inferior individuals

I feel that ideally groups have the same potential virtue that any positive collaboration does: three minds can form and integrate more ideas than one. The success of the Bauhaus was not based on Gropius's genius alone.

It's easy to imagine that one major, all-time artistic prin-
ciple can be applied to the growth of plants and plant forma-
tions, that is, the taking of mistakes as positive incidents.
To illustrate: by normal television broadcasting standards
and standards of proper reception, color lags are considered
bad mistakes. However, if this error is accepted and trans-
formed into a virtue, one is suddenly in a position to de-
velop a new, sensitive color-and-motion vocabulary that can
be employed in nonnaturalistic television programming. Ap-
plied to biology, this means that the artist, with the help
of botanists, might be able to grow miraculous sculpture-
plants by way of induced mutation.

Hardware

The increasingly mobile and versatile forms of life of the future will, more than all the burlap, denim, and leather reactionary blood-and-soil movements, bring about increasing abstinence from lustful assemblages of possessions. The frequent air traveler realizes quickly how awkward big suitcase can be. The most moving peaceful events of the recent past were the moon flights.

May we have times when experiences count more than possessions?

Flight from MARGATE to South AMERICA.

LONDON, WILLIAM TEGG

In some instances the positive role of the artist may be
rather negative. His main task may consist of keeping bad
architecture, bad art, bad profiteering away from blessed
relics of nature. Honolulu may be the door to the Hawaiian
Islands, but Hawaii would be more beautiful without it.

Heat

Although changes of temperature are among the most common and most intense of the human experiences, they have hardly been included in artistic explorations. Glowing metal is more beautiful than the "glowing color" of applied pigment.

A fireplace appeals to its users not only practically but also aesthetically. A similar combination of eye values and skin values can lead to heat sculptures that are fed electrically or by gas pipes; they are recommended for plazas and other open areas.

Because these sculptures would serve a function vital to society, they might also help people to forget about style as a primary concern of art.

Unfortunately laser beams are still narrow, weak, and ex-
pensive. As soon as they become wide, strong, and reasonably
inexpensive, one all-time dream of artists, scientists, and
practically everybody else will come true: a three-dimen-
sional display of moving images, representational or not, in
the night sky. I admit that Macy's has created early pneu-
matic sculptures, pop and crude, but I do hope that in a
more sophisticated society large-scale outdoor hologram dis-
plays will not be first used commercially.

They are the natural shelter for many kinds of art. The fre-
quently stated objective of any embracing art effort is to
turn life into art by turning art into life. Before we reach
or even approach this objective, we have to blow breath into
art by mouth-to-mouth resuscitation. Art in museums is dis-
played with imperatives attached--"Do not touch!" "Do not
take home!" "Do not change!"

Ideally, any home is a work in progress. There is a beautiful
German term for what it should not be: <u>kalte Pracht</u> (cold
glory).

In a 1960 text about ice as a material for growing and
changing sculptures as a result of induced and guided natura
processes, I presented a model for growing environments, sug-
gesting the Antarctic as a natural site. Architects' plans
for chemical or biological architecture suggest opportunitie
for the artist as a conductor of forces and processes rather
than as a Michelangelo who chisels marble fetishes.

Seasonal art works come to mind, partly inspired by snowmen,
French flower clocks, Quebec winter pageantry, Eskimo igloos
the artificial snow mountains around Mount Snow, and the ice
formations of Niagara Falls.

Treating ice with fire can turn into a study in beautiful
organic forms that make Arp's <u>Cloud</u> <u>Shepherd</u> look like a
brutal misunderstanding of nature.

The idea of edible sculptures is possibly older than art.
Its most popular relic is, goddammit, the U.S. wedding cake.
Maybe the notion of treating food as material for synesthetic
experiences should be suggested to the Howard Johnson chain
as its contribution to a serious beautification program and
to a symbiotic art-and-technology relationship.

Listening to a certain breed of professors, one has to con-
clude that their only interpretation of the role of art in
architecture, nature, and technology in a numerically grow-
ing society is in terms of design, that is, the narrow ver-
sion of what design can be, based on strict and academic
interpretations of Bauhaus principles. It all boils down to
the artist's role as designer of pots and pans, letterheads,
and magazines, maker of artsy-craftsy films, and holder of
the architect's hand while he is thinking about how artfully
to scratch-pattern the skins of his buildings.

First of all, design can
embrace everything, the
most exalted as well as
the most prosaic. So
let's not worry about the
implications of the word
"design." More important:
restricting the artist to
functional design takes
away one of his intrinsic
concerns, representation,
expression, interpreta-
tion of life through
drawing the human appear-
ance by whatever conceiv-
able technique, whether
pencil or electronic
casting by means of tele-

vision. Puristic styles like (big deal) minimal art owe the attention paid to them now to the fact that they occurred against a background of thousands of movies animated by celluloid equivalents of human beings. On the other hand, imagine movies that were analogous to primary sculpture—how lively modern sculpture would be.

Aside from that, the real inhabitant of the new artistic environment, iconoclastic or not, is every human being in it. That men and women, especially boys and girls, dress more colorfully and let their hair grow more sculpturally emphasizes the importance of the voluntary individual versus the specified stereotype.

Let's hope that the awakening out of Brooks Brothers anonymity will not be drowned by a rock music that is already (again) a perfect stereotype. One limited art form alone cannot awaken all the senses. The essential element, though, is amplification of simple sounds and a human voice in a rather unarbitrary form.

Sometimes I think that a 250-story building in the form of Sitting Bull might make just as much sense as the World Trade Center, especially ten years after the Seagram building.

in such number for and about art have been discussed, especially since the intellectualization of art (in modern art) that occurred following Chevreul, Apollinaire, Worringer, Marinetti, Malevich, that I feel that a deadline should be set, maybe August 1, 1973, after which the use of art language should be restricted to content, art itself, as opposed to comment or interpretation. Word ideas will no longer be relevant. When properly set out, reality is strong enough to permit the measurement of things by their presence and intensity, as opposed to their potential. After all, not that many good ideas have been added since Jules Verne, Paul Scheerbart, Laszlo Moholy-Nagy.

Given the advanced age of technology, it is deeds that count, not babble. We have to realize that visual or sensual evidence can lead us out of the dark ages of an archaic intellectualism in which catchwords like patriotism, America, German, or white were the pied-piped tunes of mankind's herds. You hang a sculpture in the wind, and the wind becomes visible. You talk about the wind, and the wind becomes a word. You talk about art and technology, and they turn into a phrase easily overcome or neutralized at least by words, a process also known as sloganeering.

Again: one way to do things is to do them.

and <u>son et lumiere</u> are pleasant means of emphasizing the given natural or historic beauty of a place. Christmas illumination makes me think again that there is something basically rotten about the American aesthetic sense or lack of it. Even at MIT, where there is a Center for Advanced Visual Studies, it seems to be impossible to provide Christmas trees with an illumination that is not kitsch. I have to think, forgive me, that one of the really advanced accomplishments of a Center for Advanced Visual Studies would be to supply the campus to which it belongs with decent Christmas illumination. Especially since, wonder of wonders, the Boston Common has had it for years and has set standards the world over.

One traditional aspect of art has been to make the best of limited resources and means. This principle applied to many industries bears the possibility of utilizing some of the waste of industry for artistic ends. An exchange of skills of the kind could lead to benefits for society on both sides. The reluctance of the artist to make use of what industry provides frequently puts him into the alienated position of a hermit in the woods insisting on old standards of handcrafting. Only by the sophisticated application of the experience and matter of science and industry can the artist reach a broader audience. He must not any longer bother to make his own electronic parts. He must incorporate economy and the economics of beauty in industrial production, thereby making beauty more sensible to the consumer. Resentments on both sides should be abandoned; one-sided profit-seeking should be corrected for the benefit of society.

to some degree of the industrial complex has taken place over
the past fifty years as designers have reshaped industrial
products. In many cases, increased sales have resulted. Some
products, of course, have looked prettier without being
better. A redesigned fork or a paper fork only makes sense
if it makes eating better. The designer who becomes an ef-
ficient tool of a materialistic power structure is neither
an artist nor an industrialist but a perfect bastard. Any
designer with a conscience must penetrate the industrial
power structure with the objective of humanizing industry
and helping to produce goods that serve the public instead
of exploiting it.

of beauty, sanity, and silence may be necessary in busy
cities or even in deserts or on rocky coasts. Islands of
beauty may radiate their influences into the surrounding
chaos, thereby having a dialectic effect on the whole en-
vironment. There is the thought that it may be better to
improve the forty-eight working weeks of the year instead
of making the four weeks of vacation more beautiful, saner,
and quieter.

inhabited by saints as the symbol of exclusive purity can be left alone for certain epochs. The ivory tower may be necessary as a fortress of refuge in time of war. In time of relative peace, when values can be measured by the quality of life rather than by the absence of death (or rather its presence elsewhere), every effort should be made to improve the conditions of existence in Roxbury, as against increasing the store of inaccessible aesthetic goods in hidden places of worship. To be a saint, a martyr misunderstood by society at large and understood by only a chosen few, is an easier way of life than getting one's hands dirty by attacking the problems of the streets. Not personal excellence, not even the excellence of individual work, counts in time of peace unless it adds joy to many lives. This common joy will generate its own excellence when it spreads, so that quantity naturally converts into quality.

We are no longer relying on one monk-scribe-artist who writes, reads, and illuminates the psalms for an ignorant crowd.

We have seen jewelry in which the exceptional value of the materials represents the total value of the piece. We see the opposite phenomenon now when materially worthless beads supposedly work magic. Jewelry, like clothes, takes on value when it is shaped individually and reflects the individual personality of its bearer.

The strange relationship that jewelry has to the psycho-physical meaning/appearance of halos comes to mind when we see "electric" jewelry. A portable radio or television set can be considered sensible though yet impersonal forms of contemporary jewelry. Body sensors that reflect personal emotions and features of physique may soon replace emeralds and medallions.

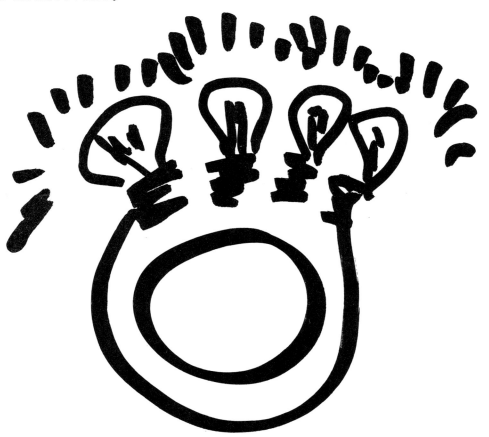

A rather complex visual joke was played when flower children
rained dollar bills on the New York Stock Exchange.

I can think of many ways to redesign almost any national
flag. The same goes for national anthems.

There should be a Day of the Visual Joke annually, a carni-
val shower for mind and body that would purify notions of
habitual, traditional dignity.

The mere fact that a sculpture moves may help the spectator
to understand the nature of movement. On the other hand, I
see no virtue per se in sculptures being kinetic because
different kinds of sculpture make people understand differ-
ent kinds of things. A kinetic object is as much of an ob-
ject as any other object if it does not turn into a more
"sociable" object by virtue of its being kinetic. A good
kinetic sculpture goes out to people and makes itself
available.

The last really striking kinetic museum exhibition I re-
member took place in 1961 at the Stedelijk Museum in Am-
sterdam. Any ambitious show after that which did not attempt
to provide subtler or more specific environmentally condi-
tioned experiences for the viewer must have seemed super-
fluous. If there is no cybernetic exchange between the
viewer and the environment, a mere show of shifting objects
will be nothing but a movable bazaar with lights flickering
and wheels rattling.

The expansive character of a truly kinetic work of art
naturally resists display of the kind that emerged from
group exhibitions of paintings and sculpture.

The academic concept of a kinetic sculpture, the kind of
object/box/item/merchandise on which something flickers or
turns, is geared to the collector's or the museum's needs:
it is designed to be hung on a wall or placed on a pedestal
The potential of a kinetic set of conditions (versus a

"kinetic object") is to create an environment on a large scale that abandons the petty, perspectival, Renaissance viewer-object relationship and provides an experience that is analogous to an experience of the universe. The viewer is surrounded by phenomena to choose from, react to, influence. The potential of kinetic sculpture is closer to Chartres and moon flight than to the reactionary and tame products of abstract expressionism.

To establish self-made elitist rules to keep anything, and any art for that matter, from being measured by crude standards of emotion and excitement of life always has been an academic game. Elitism is a particularly narcissistic form of self-delusion and intellectual cynicism. Admittedly it must take guts to look back at the life spent on painting stripes, n'est-ce pas, Michael Fried?

Kinetic art is inherently a social art. It is mature enough now to expand, to live without the babblers, and to address open minds everywhere. I find it significant that kinetic art has had a special appeal to children for a long time.

The freedom of art and artists is still severely restricted
by the artists' common habit of regarding their own navels.
Art in general has spent a lot of time and effort looking
at its own navel. In order to reorient artists' concern and
to reestablish touch with and influence on life, we raise
our eyes and look at the world beyond the limits of "art,"
and we study subject matter that is not in the files of
art history. A pleasant reader for beginners: <u>World on a
String, the Story of Kites</u>, by Jane Yolen (Cleveland and
New York, 1968).

Alexander Graham Bell's kites of 1900 to 1910 make one feel
that Kasimir Malevich and even Laszlo Moholy-Nagy were
ridden by bourgeois intellectual obsessions, always having
in mind the canvas/object, the objectification of art,
while making big speeches about revolution in art.

It is still astonishing that Tatlin was so far removed from
reality as to experiment with wing-flapping man-powered
planes for years, though his aims were far behind Leonardo's
technologically.

Looking at the larger part of present art, we can only con-
clude that the artist in general is just as bad a material-
ist as many a rich man that he criticizes. To ask high pay
for a square box made of cardboard or iron requires guts,
if no brains.

The Boston Kite Flying Festival in Franklin Park united thousands of people and, when I experienced it, produced much joy, few words, little theory, and no scholars, except as people.

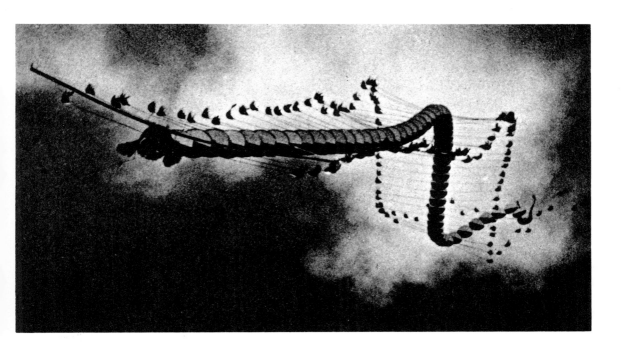

Looking at what has been advertised as land art so far could
make a clear-eyed observer feel that artists do badly with
a lot of humdrum what "real people" do well without noise.
The poor scale of land artists' actions is ironic vis-à-vis
the attempt at and pretense of doing something grandly. I
suspect that accomplishment is needed to convince people.
Words, especially too many of them, spoil good ideas.

So far the range of ideas from Group Zero has been more con-
vincing than the humble bulldozed brush strokes in the
desert. There is always the land art of the Mexican Indians
for comparison of scale and accomplishment.

Although the desert is an easy backdrop, it is obvious that
it is quite beautiful in itself and that the urban scene
and man outside the desert more urgently need art—conscious
and circumspect attempts to create a dignified human en-
vironment.

Every visit to Europe makes it clearer to me how bad an idea free enterprise is in view of the beauty needed for any landscape to be "nature." People with artists' tempers are needed to save remaining landscapes from the devouring and perennially profit-motivated tough-minded industries. Free enterprise being basically antisocial, it will swallow all the remaining landscape unless some sense of aesthetic responsibility is instilled in it.

Laser light

is one of the phenomena that demonstrate an affinity between the metaphysical and the physical. The artist's striving for pure light and the scientist's striving for pure light meet in their mutual fascination with the laser beam. Laser light's potential to become walk-through sculptural material is obvious, and so is its possibility of making "spirits" visible.

The vision of larger-than-life holograms dancing in mid-air is offered by any minute holographic image.

The visible laser beam that reaches the moon and beyond will establish credible connections between the earth and the universe.

often objected to modern art in general because they said
that they were given a set of instructions with every modern
artwork and could not understand the work unless they studied
the instructions first.

Despite much unjustified sensationalism about shows of
kinetic or light art, bazaars or not, most of these shows
can be justly considered successful in attracting huge
audiences. The liveliness of changing phenomena has rees-
tablished a good rapport between artists and laymen. With
increasing efforts to encourage the valid participation of
audiences, artists and laymen may unite over common issues
such as the aptness of public schools and public universi-
ties for the nurture of lively citizens.

Public schools in the United States are among the ugliest
and most depressing edifices ever built. They seem to be de-
signed as cattle barns, and out of them throng laymen ir-
responsible in every respect. It would be a real challenge
to artists to be asked to improve the existing public schools
by making the best of modest means. A more rewarding task in
the long run would be, of course, to help design new and
truly human public schools.

Light cure

That many people flock to southern beaches for recreation illustrates man's need of light for his health. Light art has much to do with that therapy in which light enters through the eyes into man's spirit. The application of a dose of light art may help restrict the use of drugs. I have heard many artist friends, most of them certainly more experimental and less conventional than many drug users, explain their art as an effort peacefully and unharmfully to provide food for the mind without endangering the body.

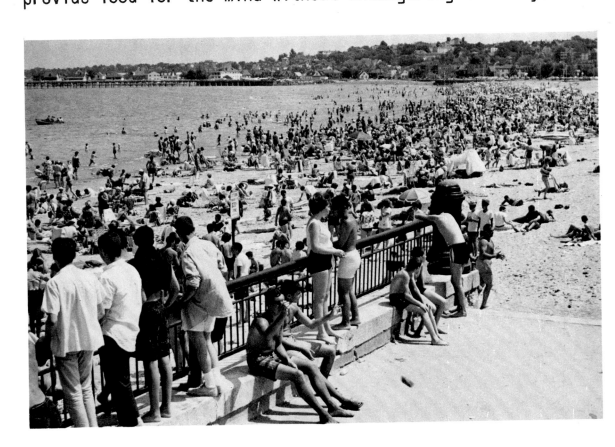

Despite trying hard to enlarge physically the scale of art, art retains one of its traditional roles: it is a parable of the universe. A light environment, while being analogous to the cityscape and the industrial landscape, is analogous to the firmament, the solar system, the cosmos, as well. A light environment reduces/expands the universe to human scale. There is psychophysical significance in the fact that a light environment envelops the viewer. He experiences space and time as opposed to observing statements about them when he reads paintings.

Most cities at night can be understood as cacophonic light amassments. Like many other things, they look pretty when you are five miles away, the current safe distance to put most common things into a comfortable aesthetic perspective.

Archaic light art, as in Times Square, Piccadilly Circus, and Brussels, may be endearing, but the examples cited are also evidence of flagrant econoaesthetic waste. Anybody can make a list of hundreds of projects for improved light environments, beginning with homes and lamps to light them.

Light is obviously a biological necessity. Man's physical being and his senses are equally kept alive and stimulated by light. The spiritual power of light is expressed in innumerable works of art of the past and by many metaphors using light images in modern languages. The role of the artist in supplying light for human needs is broadly a matter of dosage. Light quantities should be stimulating without hurting human eyes and warming without burning the skin.

The sun shows us how a powerful "light sculpture" affects us environmentally. We are not only exposing our eyes but all our senses to the sun, and the environment it creates is most obvious on the beach in summertime. A light sculpture—as opposed to a passive painting—is a source of energy, that is, the matter of sensation and its four-dimensional nature directs it (potentially at least) to the whole environment. Timing is a matter of relating light impulses to the human pulse and rhythms of visual perception.

A circumspect installation of an artistic light environment will, like ordinary lighting for lighting's sake, offer any user a set of choices so that he can influence the environment and become more than an inactive recipient, so that he can be an active creator of his own environment.

Trying to box light in cubes like paintings in frames, as many recent light artists do, means going back to the wall-hung metaphor of traditional art. Light expands characteristically and is therefore a natural environmental material.

Any space, architectural or natural, can be turned into a light environment by using electric light or fire at night and sunlight or reflected sunlight and fire during the day. Environments can be artistic as well as practical. Ideally they are both artistic and practical. Practicality, in the possible contributions of a light environment to illumination and climatization, can heighten the aesthetic efficiency of an environment; that is, the degree to which the environment positively affects its users, involves complex

human terms beyond pragmatic, technological, or economic considerations.

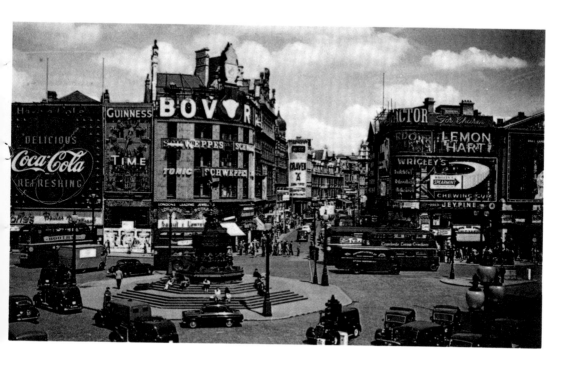

Lighting

Despite many efforts by designers, most modern lighting is cold, insufficient, aesthetically inefficient. Most electric lamps are shaped like gas lights or even older lighting devices. A proper approach to the technology of incandescent filaments and the art of glass blowing will, I hope, ultimately lead to lights that are intrinsically lamps and so will make containers superfluous. All a lamp needs to be is a bulb and a socket.

Things will change radically as soon as household electricity can be transmitted without wires.

Glowing gases make purer, more intense colors than colored bulbs.

along with northern lights, mirages, tornadoes, and cloud
formations, is among the large-scale spectaculars of nature
that set standards of intensity for the artist's efforts.
A lightning rod can be considered a most fascinating piece
of conceptual art.

Light sculpture

can be a device and an <u>objet d'art</u>. It has shape and/or performance; it gives out light but is also an ostensibly shaped object, solid, liquid, or made of light itself.

A major advantage of a light sculpture is that it can perform well without weighing much.

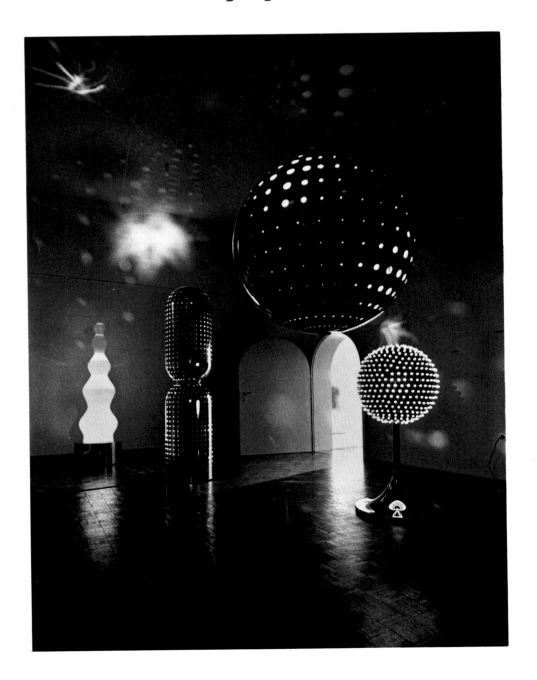

Litter

Any art class in need of materials has only to collect the litter of the streets. Empty beer cans can be made into the instruments of wind organs, pipes, and flutes, then placed on roofs and buildings or hung in trees.

Note: when you are in Switzerland, litter a little—for ecological balance.

Merck

Seven years ago a gentleman from the Merck drug company asked me to make suggestions for sculptures somewhere in its office building. He invited me to New Jersey and showed me around the labs. After looking and thinking, I suggested that Merck collaborate with me in setting up a sculptural environment employing a process of growing crystals analogous to rock candy, icicles, and stalactites. Unfortunately I never heard from Merck again.

Growing processes that lead to art and architecture, organic and inorganic chemistry providing new ways of "sculpting" and "building," can not only create new shapes and skins of shells and hives of living (and things to look at) but they can also create more healthful living conditions—purer air, for example.

Turning a stone Egyptian lotus column into a living lotus column that provides roof and shelter would literally give us a "house of flowers."

Migrating artworks or groups of artworks can float or swim like fish, fly like cranes, or fade like the setting sun. Migrating man carries portable electronic charms and receives universally spread tele-information. Migrant apparitions could be planted into the sky like wandering clouds of snow.

created by meteorologists, geologists, and artists can be
a perfect form of immaterial art and of theater in the sky.

The preservation and purification of the environment is now
an important issue. Believing as I do that beauty is an ex-
pression of accomplished economy and that aesthetic theory
deals with a set of economic conditions, I suggest that
MIT set up a serious and fast-working ecological study team
that investigates aesthetic efficiency as a standard for en-
vironmental work. I guess that such efficiency is based on a
sensitive and forward-looking understanding of human needs
far beyond material ones alone.

The only models for a rather complex aesthetic efficiency
that I can think of right now are certain theatrical pro-
ductions.

of a new kind that can heat plazas, light the environment, and clean the air could be both practical and sensually affecting. Many will have to point toward the sky or float in the air as life aims away from our mother planet.

I do not understand why the flag of the United Nations could not have been taken to the moon. Like the sky, the moon represents a region unspoiled so far. From now on it should be touched with care and circumspection so that it maintains its natural beauty. To abuse the moonscape for atomic tests would prove as disastrous as using the Bikini atoll for war purposes. And we should not get rid of our Con Edison power plants and other poison-spewing mills by relocating them on the moon. Maybe installations on the moon could be subterranean as a rule.

An earth-to-moon-and-vice-versa light beam could express communication as we find it when two boys flash their lights at each other from two distant trees in the night.

WIND MANUAL

Part II
Wind Manual, I, II, III

The Wind Manual, I, II, III, was rendered to show basic
ideas about simple flying objects to teachers and students
of elementary schools, high schools, and art schools in
Pittsburgh, Pa., in preparation for one event of the City-
thing Sky Ballet in Pittsburgh, April 1970.

OTTO PIENE

WIND

MANUAL

III – '70

HONOLULU
CAMBRIDGE / MASS.
DÜSSELDORF / PITTSBURGH

WIND MANUAL

CONTENTS

I FLAGS: 1) PATERNS

 2) SHAPES

 3) MAKING
 (TECHNIQUES)

 4) MOTIFS (PATERNS
 LETTERS
 DRAWINGS
 FIGURES
 PRINTS
 5) RIGGING ~~PHOTOS~~)
 HOISTING

II BANNERS

III RAGS & BAGS

IV RIBBONS

(OVER

CONTENTS [2, CONT.]

I FLAGS

1) PATTERNS

PATTERNS

FRINGES →

(SEWN)

I FLAGS
1) PATTERNS
2) SHAPES
3.) TECHNIQUES

W/ TWO PERSONAL FLAGS

MY TWO PERSONAL FLAGS

I/1/2/3)

(SEWN OR PAINTED)

I FLAGS

1) PATTERNS

3) TECHNIQUES

VARIAT.S ON T. RAINBOW F.

VARIATIONS ON THE RAINBOW F.

(SEWN, PAINTED, TIE-DYED)

I FLAGS

2) SHAPES

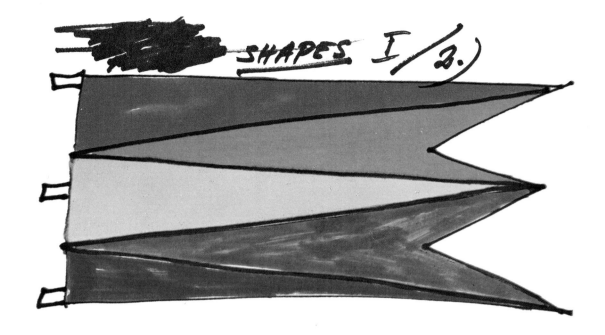

SHAPES. I / 2.)

(SEWN, BATIK ETC.)

I FLAGS

2) SHAPES
CONT.D

I / 2.)
CONT. D

SEWN

I. FLAGS

2.) SHAPES
CONT. D

SEWN
LIGHT MATERIALS
(SILKS, NYLON ETC.)

I FLAGS

3) MAKING (TECHNIQUES):

SEWING
WEAVING
EMBROIDERING
ETC. ETC.
APPLICATIONS
KNITTING
KNOTTING
ETC.
PAINTING
DYING
SPRAYING
TIE - DYING ETC. ETC.

OVER

OVER FROM I/3)

I FLAGS

3) MAKING
(TECHNIQUES)

CONT.D

HEAT-SEALING
PASTING
TAPING
CUTTING (HOLES, P.E.)

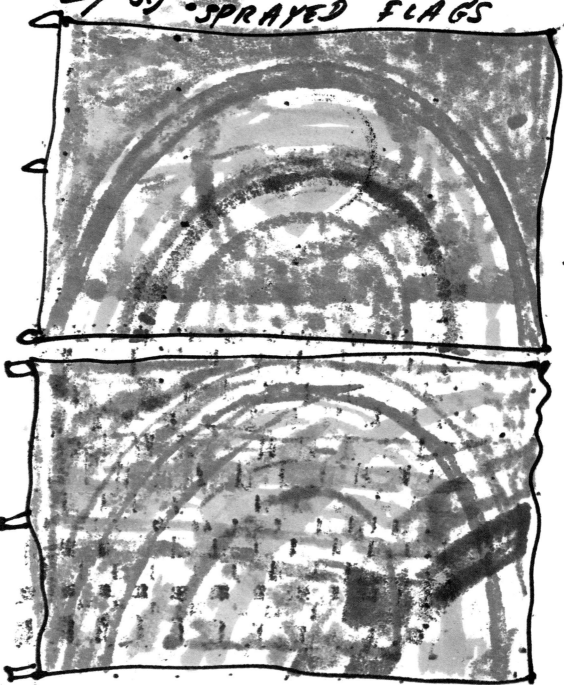

I FLAGS

3.) TECHNIQUES

DAYGLOW ETC.

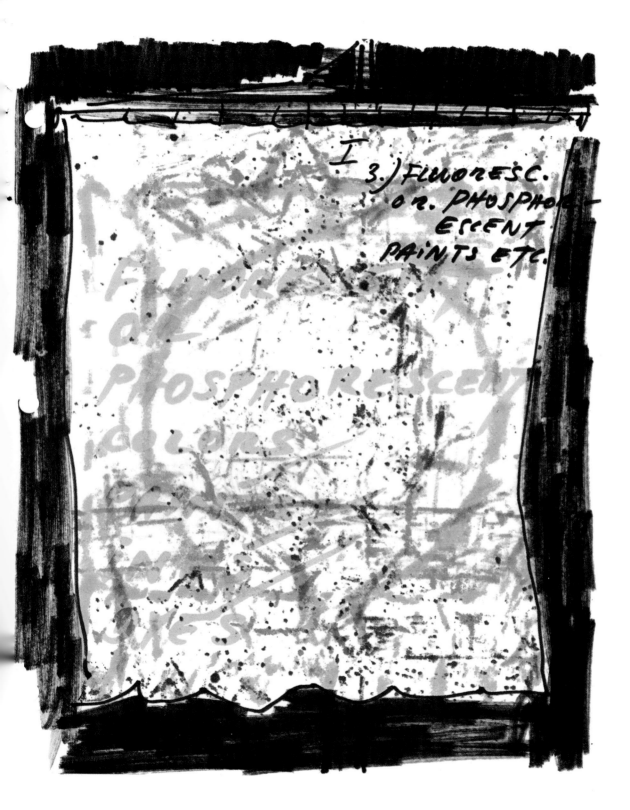

I

3.) FLUORESC.
or. PHOSPHOR-
ESCENT
PAINTS ETC.

I FLAGS

3) MAKING
(TECHNIQUES)
TIE-DYING

TIE-DYED

I FLAGS

3) MAKING:

 CUTTING

I FLAGS
3) MAKING: CUT CLOTH

THE ULTIMATE PEACE FLAG

I FLAGS

4) MOTIFS

PATTERNS
LETTERS
DRAWINGS
FIGURES, PAINTED
SILK—
SCREENED
PHOTO-PRINTED

I (N.) LETTERS

BLACK
& WHITE

BLACK
WHITE
& RED

BLACK

SEWN APPLICATIONS OF CLOTH

I FLAGS

4) MOTIFS

(LETTERS)

I FLAGS

4) MOTIFS
(DRAWINGS
 FIGURES
 PRINTS
 PHOTOS)

II BANNERS

I FLAGS

4) MOTIFS

II BANNERS

I/4J & II

BANNER

OLE

WILDLIFE FUND

SEWN / PAINTED / GLUED

SEWN

APPLICATION
OR PAINTING
OR PAINT

I FLAGS

 4) MOTIFS

 COAT OF ARMS

II BANNERS

I/4 II DANNER

MORE SKY

SILK-SCREEN, SPRAYED, PAINTED, GLUYED

COAT
OF
ARMS

CYRIL DRY CLEEN
IIII

SEWN APPLICATIONS OF CLOTH,

O. P.

WIND
MANUAL

2ND INSTALLMENT

-IV- 70

III
RAGS & BAGS
1.) RAGS

$\pi - RAG'S$

III

2y BAGS

MATERIAL:
PAPER

III BAGS

2.) CONT.D

MATERIAL :
DIFFERENT KINDS
OF PAPER

IV RIBBONS

1.) STRAIGHT

IV RIBBONS
1) STRAIGHT

MATERIALS:
FABRIC OR
PAPERS OR
PLASTIC FOILS

IV RIBBONS

2.) TANGLED UP
(IN STRETCHED WIRES)

IV RIBBONS /
2.) TANGLED UP
IN STRETCHED
WIRES

IV RIBBONS

3.) ATTACHED TO HIGH POINTS

IV RIBBONS

3.) ATTACHED
TO HiGH
POiNTS

V CONTRAPTIONS

1.) HARD AND SOFT MATERIALS

(SCARE CROW)

V CONTRAPTIONS

1.) HARD AND SOFT
MATERIALS
(SCARE CROW?)

POLYETHYLENE
IS VERY WELL
SUITED TO
WRAP

LOOSELY
LITTLE MONSTERS

V CONTRAPTIONS

2) WINGED TENT

V CONTRAPTIONS
2.) WINGED TENT

V CONTRAPTIONS
3.) ODD BOX KITE

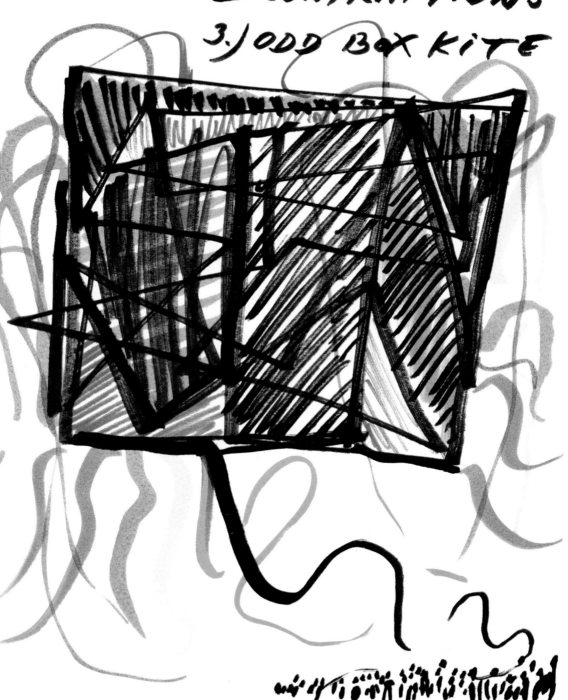

Ⅴ CONTRAPTIONS
3.) ODD BOX KITE

V CONTRAPTIONS

4.) SPOOK HOUSE

Ⅴ CONTRAPTIONS
4.) SPOOK HOUSE

VI WIND SOCKS

1.) RIGGED TO WIRING

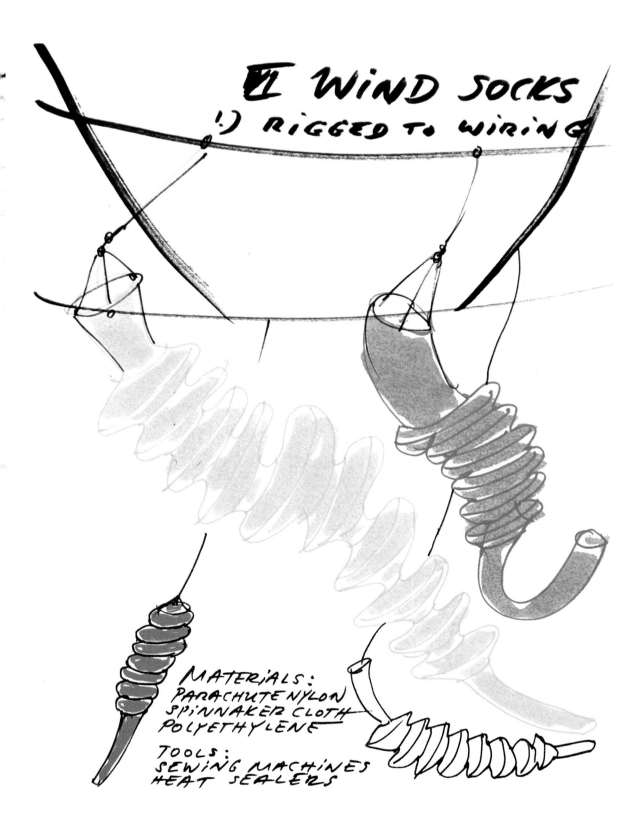

VI WIND SOCKS
1.) RIGGED TO WIRING

MATERIALS:
PARACHUTE NYLON
SPINNAKER CLOTH
POLYETHYLENE

TOOLS:
SEWING MACHINES
HEAT SEALERS

VI WIND SOCKS

2.) RIGGED TO FLAGPOLES

VI WIND SOCKS
2.) RIGGED TO FLAGPOLES

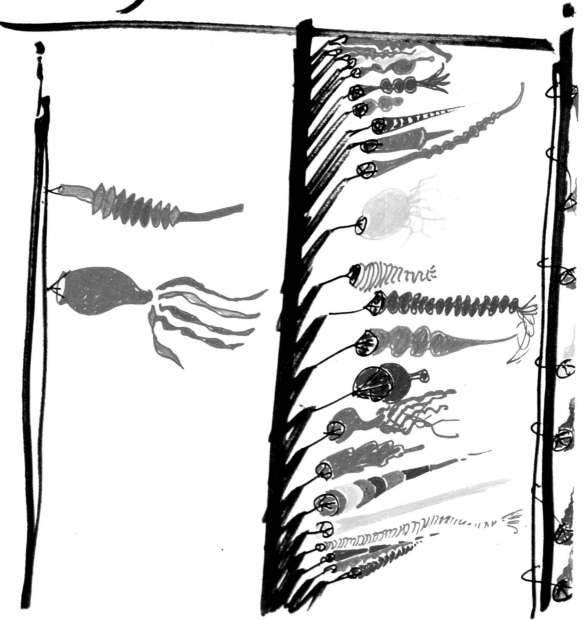

O.P.

WIND MANUAL

THIRD INSTALLMENT

VI VII
RIGGING OF A WINDSOCK

RIGGING OF A
WIND SOCK

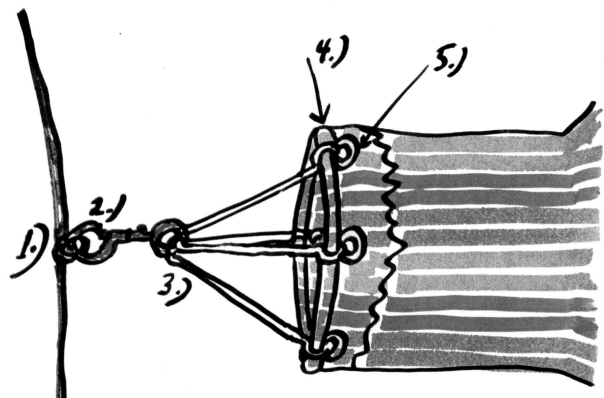

1. LOOP IN OR EYE ON ROPE OF
 FLAGPOLE
2. METAL SNAP
3.) NYLON OR HEMP ROPES
4.) FOLD IN WINDSOCK WITH
 RUBBER-COATED STEEL
 CABLE INSIDE
5.) GROMMET

VII RIGGING

RIGGING

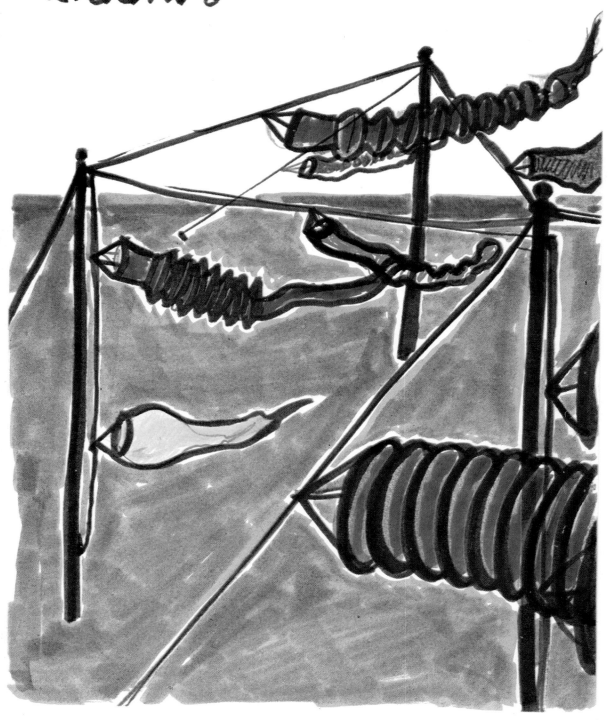

VI

WIND SCULPTURE

VI WIND SCULPTURE 1)

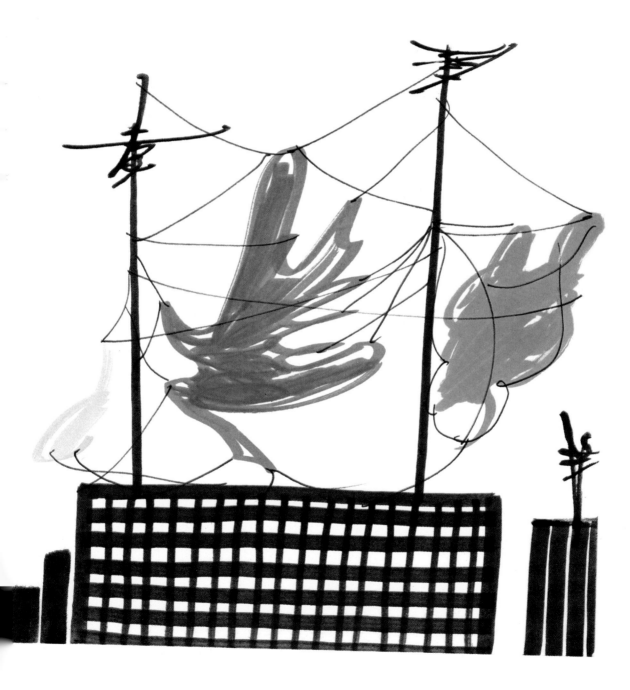

VI
WIND SCULPTURE 2)

WIND SCULPTURE 2.)

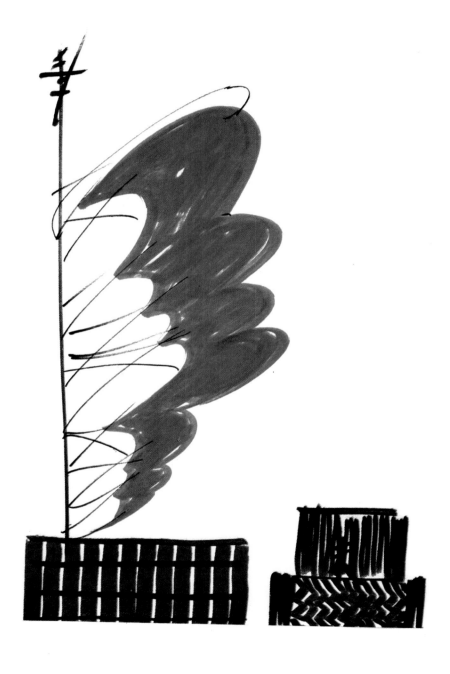

1.) CARRYING
WINDSOCKS

VIII 1) CARRYING WIND SOCKS

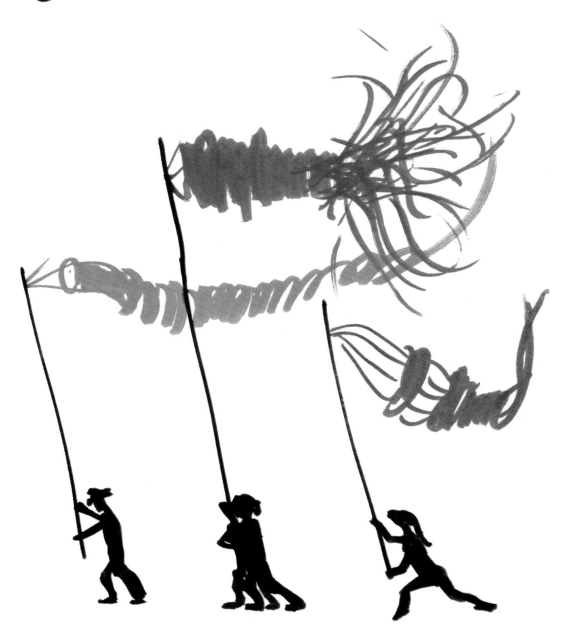

VIII

2.) DANCING

2) DANCING

VIII

3.) BLOWING UP
COSTUMES

3.) BLOWING UP COSTUMES

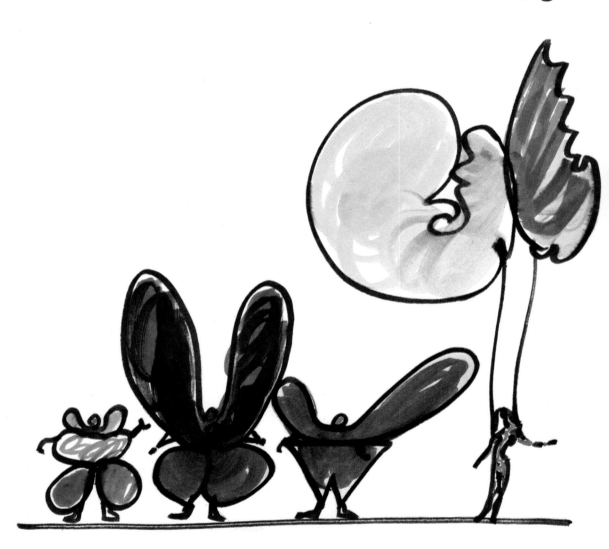

VIII

4.) FLAG-SWINGING (BRANDISHING)

VII. FLAG-SWINGING
(-BRANDISHING)

VIII 5) FLAG-MOVING -
 INFLATING

6.)

WIND — SKY — BALLETS

6J WIND-SKY BALLETS
HELIUM-INFLATED TUBING

VIII WIND-SKY-BALLETS

IX MATERIALS

TOWED WIND SCULPZ

VIII WIND–SKY–BALLETS
I. MATERIALS
TOWED WING SCULPTURE

<u>VIII</u>
WIND — SKY — BALLETS

<u>IX</u> MAT.S

SKY- WRITING

JIM WIND - SKY- BALLETS
IX MAT.S
SKY-WRITING

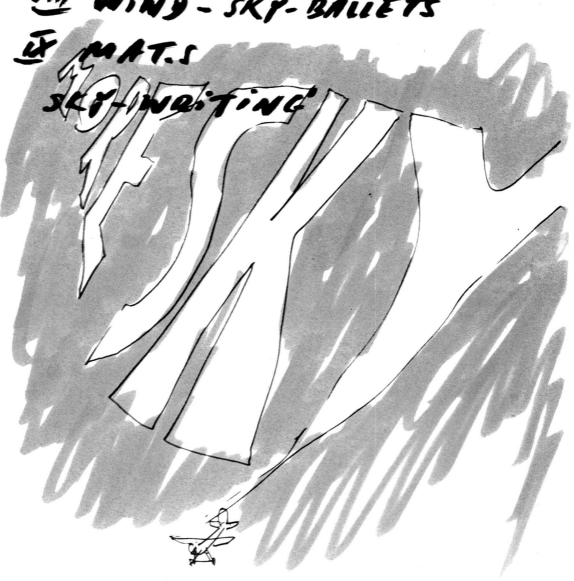

VIII WIND- SKY- BALLETS
IX MAT.S
RED HELIUM SKY LINE

Photos by the author unless otherwise noted.

page 13
The Thinker, Auguste Rodin. Courtesy Rodin Museum,
Philadelphia.

page 16
Los Angeles, California.

page 22
Otto Piene, Olympic Rainbow. Munich, September 11, 1972.

page 30
In and Over Mardi Gras. Lithograph from Otto Piene's port-
folio, Sky Art. Tamarind, Los Angeles, California, 1969.

page 37
Otto Piene, Towed Wind Sock. Deep Creek Airport, Maryland,
May 16, 1970. Sponsored by the Smithsonian Institution,
Washington, D.C.

page 39
Migrant Apparition. Lithograph from Sky Art.

page 40
Winged Nike from Samothrace, about 190 B.C. Louvre, Paris.
Hirmer Fotoarchiv München.

page 42
Simon Rodia, Watts Towers, Watts, Los Angeles, California.
Photo: Gordon N. Converse, Chief Photographer, The Christian
Science Monitor.

page 46
Scene from Otto Piene's sky event, Lift and Equilibrium, at
the Massachusetts Institute of Technology, Cambridge, Massa-
chusetts, June 25, 1969. Sponsored by The Center for
Advanced Visual Studies and Committee on the Visual Arts,
MIT. Photo: Nan R. Piene.

page 48
Imagine a City Below by Night. Lithograph from Sky Art.

page 49
Splash of a milk drop, photographed at 1/10,000 of a second
exposure. Photo: Dr. Harold Edgerton, MIT.

page 56
Honore Daumier's lithograph Pygmalion. A sculpture comes to
life upon the artist's wish. Courtesy Museum of Fine Arts,
Boston.

page 57
Otto Lilienthal in his 1896 glider. Archiv Krueger.

page 66
Karl Heinz Stockhausen. Photograph by Bernard Perrine.

page 69
Mathias Grünewald, <u>Resurrection</u>, ca. 1505–1515. Isenheim altarpiece, Colmar Museum.

page 70
Niagara Falls. Niagara Falls, New York.

page 70
New York City blackout, February 7, 1971. Wide World Photos.

page 73
<u>Red Helium Sky Line</u>, one event of Otto Piene's <u>Citything Sky Ballet</u>, Pittsburgh, Pennsylvania, April 17, 1970. Sponsored by Citything of Pittsburgh and the Pittsburgh Council of the Arts. Photo: Walter Seng.

page 75
Large balloons in the Tuileries, Paris. Gordon Bennett Cup, 1906.

page 78
Thrust-augmented Delta launches Pioneer. Photo: U.S. Government Printing Office.

page 79
Title lithograph, <u>Sky Art</u>.

page 81
Photograph of the author. Installation of windsocks for city
planning conference, "Hennepin, The Future of an Avenue,"
Minneapolis, Minnesota, April 24-25, 1970. Sponsored by
Walker Art Center, Minneapolis, Minn. Photo: Eric Sutherland,
Walker Art Center.

page 82
Otto Piene, wind sculpture installation. St. Catherine's
College, St. Paul, Minn., October 5-9, 1970.

page 85
Naxian sphinx from beside the Sacred Way, Delphi, before
560 B.C. Courtesy Delphi Museum. Hirmer Fotoarchiv München.

page 86
Scene from Lift and Equilibrium. Photo: Nan R. Piene.

page 87
Yves Klein

page 87
Old Faithful Geyser, Yellowstone Park, Wyoming.

page 90
Simon Rodia, Watts Towers. Photo: Gordon N. Converse, Chief
Photographer, The Christian Science Monitor.

page 93
Photo: Pearl Jusem, Mario Furtado.

page 99
Photo: GAF Corporation.

page 112
Main spire of the world's tallest cathedral, Ulm, Germany.

page 119
Chinese dragon kite. Photo: Chinese Information Service.
Courtesy World Publishing Company.

page 124
Revere Beach, Massachusetts. Photo: R. Norman Matheny, Staff
Photographer, The Christian Science Monitor.

page 127
Piccadilly Circus

page 130
Otto Piene, Light Sculptures, Galerie Heseler, Munich, 1972.
Photo: Wolf Huber.

page 132
Flos Caeli Vulgaris. Lithograph from Sky Art.